Mariolina Olivari

GIOVANNI BELLINI

SCALA/RIVERSIDE

CONTENTS

© Copyright 1990 by SCALA, Istituto Fotografico
Editoriale, S.p.A., Antella (Florence)
Translation: Anthony Brierley
Editing: Susanne Kolb
Layout: Fried Rosenstock and Ilaria Casalino
Photographs: SCALA (M. Falsini and M. Sarri) except
nos. 3 and 41 (Accademia Carrara, Bergamo); nos. 11,
12, 62, 66 and 84 (by courtesy of the National Gallery,
London); nos. 14 and 38 (Gemäldegalerie, Berlin-
Dahlem); nos. 52, 53, 63, 77, 81, 82 and 83
(by courtesy of the National Gallery of Art, Washington);
no. 79 (Musée des Beaux-Arts et d'Archéologie,
Besançon); no. 80 (Kunsthistorisches Museum, Vienna)
Produced by SCALA
Printed in Italy by: Amilcare Pizzi S.p.A.-arti grafiche
Cinisello Balsamo (Milan), 1998

Published by Riverside Book Company, Inc.
250 West 57th Street
New York, N.Y. 10107

ISBN 1-878351-09-5

The life of Giovanni Bellini still eludes us, and his main works are relatively poorly documented; he is, however, universally acknowledged as a figure of remarkable stature, and was so even in his own lifetime

If we are to believe Vasari, who declared him dead in 1516 at the age of 90, then the year of his birth (otherwise completely uncertain) ought to be 1426. Yet Vasari's testimony contradicts what is documented by the family. Indeed, the wife of Jacopo Bellini, Anna Rinversi, wrote her will in expectation of the birth of her first child only three years later, in 1429. Moreover, according to sources of Bellini's time (and therefore prior to Vasari), the couple's firstborn child — unless of course it was a third brother, the recently discovered Niccolò (Meyer Zur Capellen, 1985), or Nicolosia, the only female child — ought to have been Gentile, who was always recorded as Giovanni's elder brother. The date of his birth should therefore be moved forward a few years, to 1432-33, or even later. In November 1471 Anna Rinversi, already a widow of Jacopo, who had probably died a few months earlier, wrote her final will, leaving all her possessions to Niccolò, Gentile and Nicolosia. Giovanni is not even mentioned. This led G. Fiocco, in 1909, to advance the theory that he might have been born of a different mother, either married to Jacopo before Anna Rinversi, or involved with him in an adulterous relationship: a somewhat adventurous speculation perhaps, which critics have received with great caution in the absence of more solid evidence.

About the beginning of Bellini's career there is still considerable uncertainty and disagreement among critics. The start of his activity as an artist must be fixed around the years 1445/1450, but as yet none of the works connected with his name, which are datable to those years, have been unanimously attributed to him. On works like *St Jerome Preaching to the Lion* (Birmingham, England, Barber Institute) or the *Crucifixion* (Milan, Museo Poldi Pezzoli), in the past thought to be among the probable candidates to occupy first place in the artist's catalogue, negative judgements now prevail, since certain recent critics have relegated them to the generic *mare magnum* of the rich contemporary Venetian production or to the family workshop. Undoubtedly, the early works of the young Bellini must have revealed a certain inexperience, which in their harshness betrayed the influence of the Vivarini family, besides the natural influence of his own father, under whose shadow, like his brother Gentile, he certainly received his early education. By the first certain date which concerns him, the 9th of April

1459, when he appeared as a witness for the Venetian notary Giuseppe Moisis, Giovanni already lived on his own, at San Lio, although the collaboration with his father must have continued, at least as far as some important commissions were concerned.

According to Fra Valerio Polidoro, in fact, in 1460 with Jacopo and Gentile he signed the Gattamelata altarpiece for the basilica of Sant'Antonio da Padova, which was to be placed in a newly-founded chapel dedicated to St Bernardino and St Francis. Unfortunately the painting has been lost, even if recent attempts have been made to identify one of its main panels in various paintings on wood (Eisler, 1985; Boskovits, 1985), in which the hand of Giovanni is nonetheless absent.

The Gattamelata altarpiece would have been a key work for understanding and distinguishing the exchanges and differences which had already emerged by that time among the three painters, and the degree of independence and artistic maturity expressed by the youngest of them. There is no doubt, however, that outside the family workshop other experiences had attracted Giovanni's attention. Two artistic influences, the Byzantine and the Flemish, both important in Venice as a result of its economic and commercial life, would always form the basis of many of his ideas; the iconic majesty of the former and the analytical precision of the latter were teachings which would never be forgotten. The works left by Donatello in Padua in the course of his ten-year sojourn in the city (1443-53) formed another fundamental point of reference. Of enormous importance, finally, was his contact and acquaintance with Andrea Mantegna, who in 1453 married his sister Nicolosia.

The importance of Mantegna for Bellini should not be measured solely in interpersonal terms. Mantegna, indeed, also represented a link with Tuscan and Florentine art which — with the important exception of Donatello, above-mentioned — had not until then affected Bellini. The study of classical art, which Mantegna had assiduously cultivated, in the footsteps of Squarcione (who was a remarkable collector of antiques), was certainly a further stimulus to which the Venetian artist responded with intelligent enthusiasm.

As we have said, attempts so far to attribute paintings to the artist's early activity, in the absence of sure evidence, have led to dissension and yielded somewhat scanty results. To find any significant measure of agreement, we must look to the years immediately prior to or following 1460. However, the series of "Madonna and Child" paintings, which constitute one

3

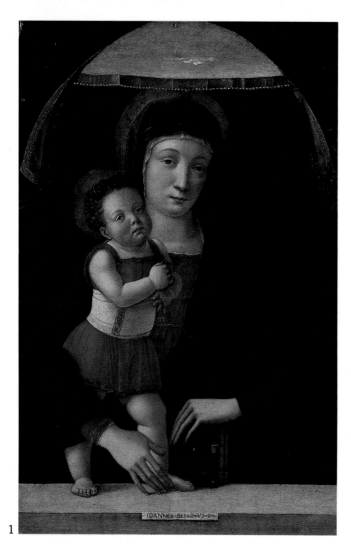

1

1. Madonna and Child
47 x 31,5 cm
Pavia, Museo Civico Malaspina

2. Greek Madonna
82 x 62 cm
Milan, Brera Gallery

of the most distinctive themes in his art, was started in his youthful years. Their execution and multiplication in the decades to come was the fruit of a considerable contribution by the busy workshop that would collaborate with the painter and to which some of the Madonnas, signed with the master's name for reasons of prestige, must be at least partially attributed.

The incidence of this type of work was not peculiar to Bellini alone. Small and medium-small devotional images destined for private and family ownership were a distinctive feature of late 15th-century Venetian painting, and in their diffusion Humphrey (1987) even sees the beginnings of private collecting.

Bellini's paintings are distinguished however by a strange, subtle tension that always binds the mother and child in a relationship of profound pathos. The models for these Madonnas were the numerous Byzantine and Graeco-Cretan icons which circulated in Venice, and which Bellini occasionally transposed with absolute precision. Yet the static stereotypes of the Eastern images were radically altered and reinterpreted by him with a lyricism and poetic sensibility that unmistakably animates the figures and puts them in intimate contact with the spectator.

To a slightly later date than that indicated by Pignatti, around 1450-55, the still harsh *Madonna and Child* of the Museo Civico Malaspina in Pavia must be ascribed. Originally assigned to Bartolomeo Vivarini by Morelli, then to Bellini by Cavalcaselle onward, then attributed to Lazzaro Bastiani by Heinemann (1962) and Robertson (1968), and finally to Bellini by Huse (1972) and Peroni (1981), this small panel is very closely related to the less disputed *Madonna and Child* of the John G. Johnson Collection in Philadelphia. The slender hands and iconic immobility still reveal the influence of Jacopo and the Vivarini family, while the boldly delineated line of the Child's figure and his transparent garment possibly derive from Squarcione, who was undoubtedly an inspiration to the young Bellini. Even more reminiscent of both Squarcione and Mantegna is the *Lehman Madonna* (New York, Lehman Collection), which may be dated to around 1460. The Mantuan influence is accentuated by the same physiognomical typology of the figures — the Virgin with a triangular face, the Child robust and squared — and by the leafy festoon hanging above, for once borrowed from frequent similar motifs which Mantegna, between naturalism and refined iconological intellectualism, had assimilated from his own teacher.

However, of all the still youthful Madonnas (dating indeed to around 1460) the masterpiece is the so-called *Greek Madonna* of the Brera Gallery in Milan, which entered the Museum in 1808 following the Napoleonic repression. It was originally in the Ducal Palace in Venice. According to Pelliccioli (quoted in Bottari, 1963) the figures were originally set against a gold background, on which the words "Mother of God" and "Christ" were written in Greek (hence the name of the painting). Obviously, a background of this type would have made it archaic and "archaizing", considerably accentuating the Byzantine appearance of the panel, a veritable Marian icon. The 1986 restoration has established that the still remaining traces of gold beside the Greek letters were a 16th-century addition, while Bellini had originally conceived the sky as it appears now: blue and almost entirely covered by a small curtain held up by a cord. Over the traditional preparatory ground (gypsum and animal glue) he had

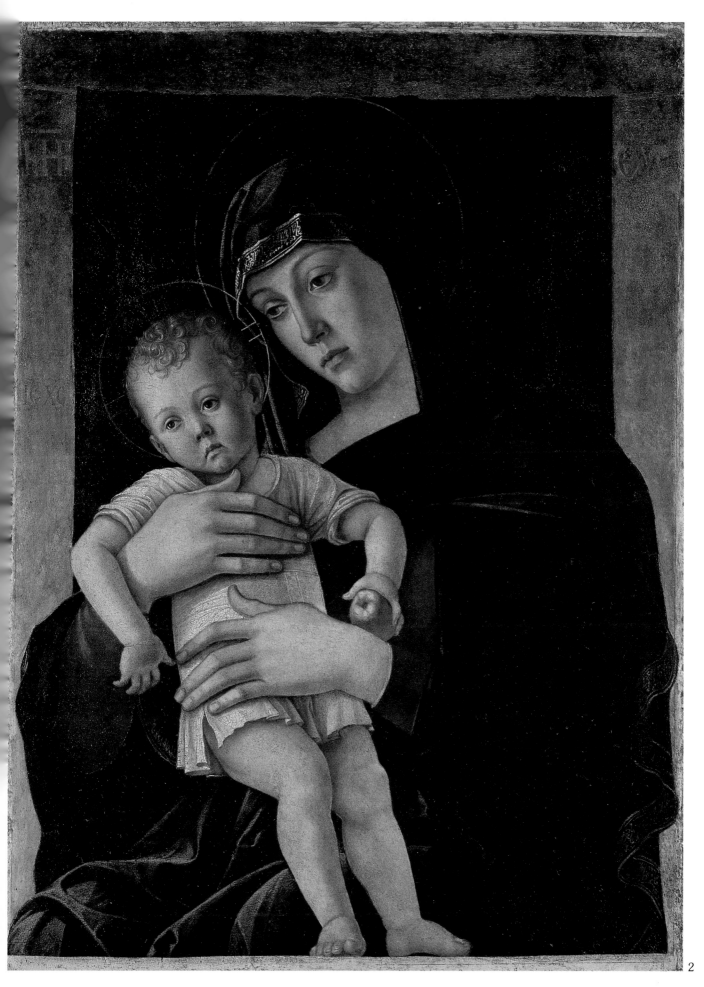

3. Pietà
52 x 42 cm
Bergamo, Accademia Carrara

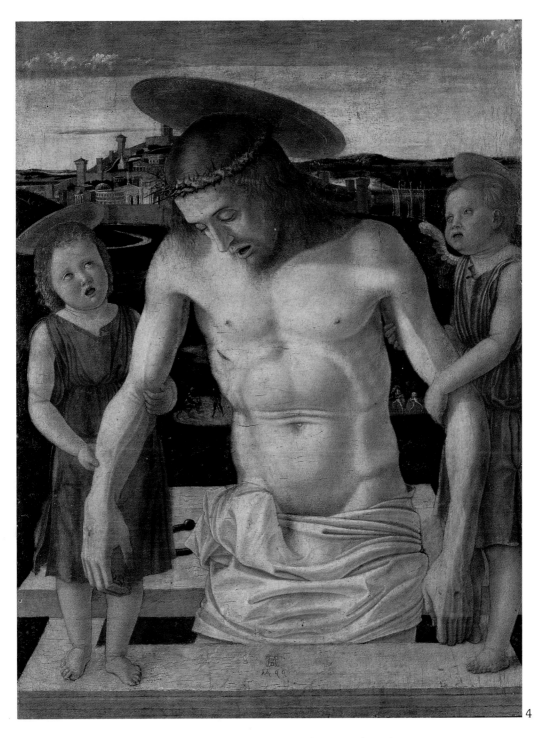

4

4. *Dead Christ Supported by two Angels*
74 x 50 cm
Venice, Museo Correr

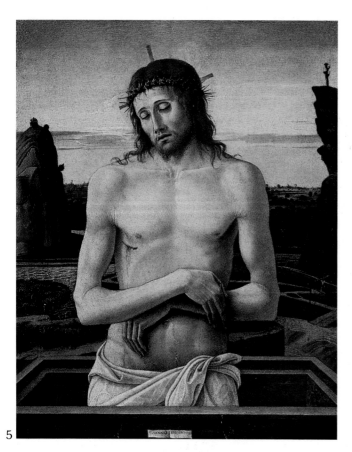

5. *Pietà*
48 x 38 cm
Milan, Museo Poldi Pezzoli

the artist's culture owes to this heritage.

Another recurring theme in Bellini's work is the "Pietà". With a highly reasoned study, Hans Belting (1985 and 1986) has demonstrated, with this subject too, the Byzantine origin of the *imago pietatis* iconographical models used in Venetian art. Venice, furthermore, was responsible for the introduction in the West of the so-called "Passion Portraits", whose function was to establish an empathetic dialogue between the dead Christ with the wounds of the martyr and the faithful contemplating Him. The faithful, besides being moved by the sacrifice of Christ, draws consolation for his own pain through the observation of divine suffering.

In Bellini's work, for example, the *Pietà* of the Accademia Carrara in Bergamo and that of the Museo Poldi Pezzoli in Milan are the prototypes of a series of variants showing the body of the dead Christ over the sarcophagus, with his head bowed and his hands positioned as if for burial. This is an iconography that originated in Constantinople, even if in Italy it was thought to derive from a famous miraculous Roman mosaic-icon, the one of Santa Croce in Jerusalem, which according to legend had appeared during Mass to Pope Gregory the Great.

The Bergamo painting, belonging to the Lochis Collection, is a harsh work, marked by a dramatic force which, in rather uncustomary fashion, the artist renders with the expressionistic masks of suffering of the Madonna and St John. The hands of the mother and son are clasped tightly together in a strong plastic join of Crivellesque inspiration, which in the past led Arslan to suppose it was the work of a Ferrarese master. Nor should we underestimate the importance that the particular fascination of the Paduan altar of the Saint still held for Bellini at this time (between 1455 and 1460).

Already more sober and composed is the *Dead Christ Supported by Angels* of the Museo Correr in Venice, which at the bottom in the middle bears the spurious date of 1499 and the similarly spurious initials of A. Dürer. This work was in fact attributed to Dürer in the Correr Collection, of which it originally formed part. It is a still fully Mantegnesque work, and datable to well before the date inscribed, possibly to around 1460. The bold line reaches its greatest tension in the draping of the loin-cloth and the abandoned hands of Christ: such is the insistence of the outlines and the subtle and hard emphasis of the shaded areas that it recalls the stone-like linear severity of the Ferrarese artists.

The *Pietà* paintings of later years (Rimini, Pinacoteca Civica; Milan, Museo Poldi Pezzoli) are, compared to this one, pervaded by a poignant and highly personal lyricism, which has the effect of transfiguring the divine drama into an expression of intense grief and infinite melancholy.

sketched out the preliminary drawing, marking in with extreme precision even the chiaroscuro with subtle and highly regular criss-cross strokes which can be seen in infra-red photography. This technique used by Bellini must have been famous if Paolo Pino in his *Dialogo di pittura* (1548) writes that "drawing the painting with such extreme diligence, composing it with chiaro and scuro as Giovanni Bellino was wont to do" was to be discouraged "for it is work thrown away since everything must be covered with the colours".

This type of drawing shows similarities with the rigorous Flemish constructive technique, though under closer scrutiny it appears to be aimed at a search for a much more solid and volumetrically constructed plastic quality. The delicate imperturbability of the Madonna, which would always remain a distinctive feature of Bellini's Virgins, shows not only its aforementioned Byzantine-iconic roots, but also how much

The Mantegnesque phase

The Mantegnesque phase comprises several fundamental works. Included among them is the *Crucifixion*, formerly in the Venetian church of San Salvador and now at the Museo Correr in Venice, whose chronological placing before or after the *Transfiguration* in the same museum has been a matter of some uncertainty. Certainly the anguished forms and the meticulous arrangement of the elements are characteristics that appear extremely early in Bellini's career, and for this reason the period between 1455 and 1460, coinciding with the presence of Mantegna in Venice, seems the most plausible moment for its execution. The landscape, though vast and expanded, is not yet conceived as a whole, but built up piece by piece according to an intellectual model filtered through the Gothic experiences of Jacopo. The figures are slender and sharply defined, and their grief, sculpted with raw pathos in the half-open mouths and extreme boniness of the bodies, is echoed in the stony contours of the landscape. These features had led Cavalcaselle (subsequently followed by Burckhardt and L. Venturi) to ascribe the painting to the Ferrarese artist Ercole de' Roberti; it was Morelli (1886) who first recognized an early work by Bellini in the univocal vibrancy of man and nature, and in the still youthful aspiration to a panicky atmospheric effect.

In this *Transfiguration of Christ*, of the Museo Correr 10 in Venice, the composition shows Elijah and Moses on Mount Tabor on either side of Christ, while below

6-8. Crucifixion and details of the landscape
54,5 x 30 cm
Venice, Museo Correr

6

7

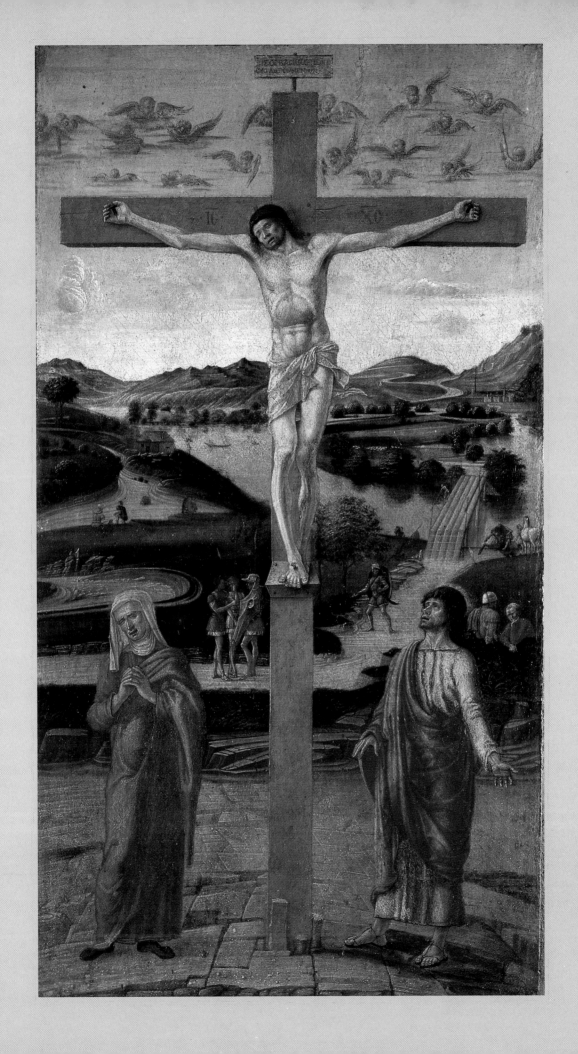

9

them are the disciples Peter, James and John blinded by the vision, according to the iconography suggested by the Synoptic Gospels. The work was for long attributed to Mantegna (whose spurious initial can be seen below right), so close is Bellini's painting to the work of his brother-in-law in this period. The composition was conceived according to a stratified ascending movement culminating in the figure of Christ, who is clothed in an ethereal pearly-white robe. The figures' shoulders and heads are forced into extreme foreshortening, dictated by the suggestion of the extraordinary Mantegnesque talent for perspective, but the stretch of
9 landscape on the left is already expanded into an image of moving realism.

The second and final version of the theme of the Transfiguration, which came much later, is the one
39 housed in the Museo di Capodimonte in Naples, dated between 1490 and 1495. Signed IOANNES BELLI / NUS ME PINXIT, it is characterized by the incandes-

9, 10. Transfiguration of Christ and detail of the landscape
134 x 68 cm
Venice, Museo Correr

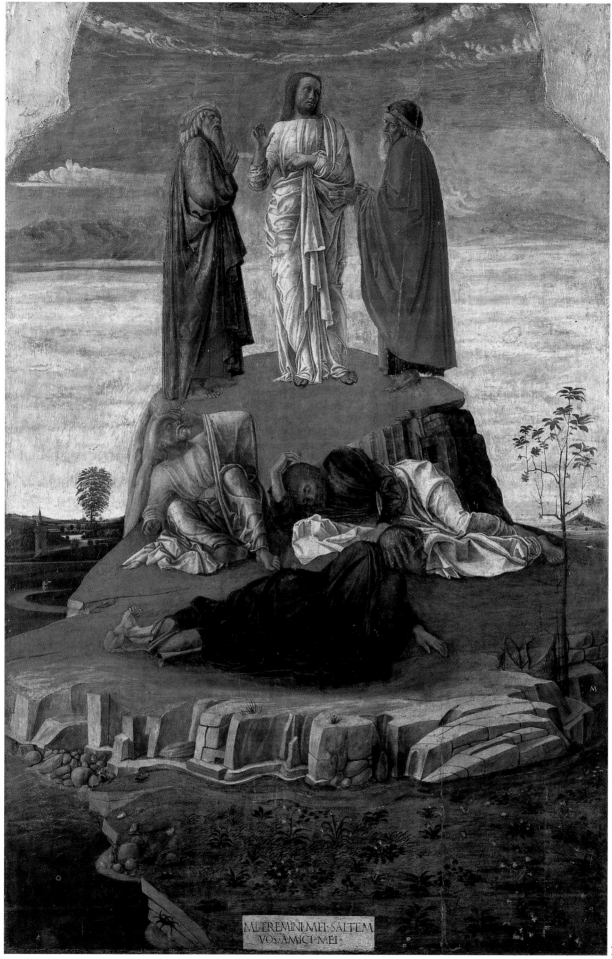

MISEREMINI MEI SALTEM
VOS AMICI MEI

cent geometric quality of a drapery that becomes almost silky in its changing shades.

A fundamental work for measuring the relationship that existed between the two brothers-in-law is the
11 *Agony in the Garden* of the London National Gallery. A fairly strong resemblance links this work with the
12 analogous subject painted by Mantegna in 1459, possibly for Giacomo Marcello, now at the National Gallery in London. Indeed, both works were for long considered to be by Mantegna. The atmosphere is leaden and rarefied, and the harsh, barren landscape retains some of the strong elemental emotions of the primitives (in fact much of the setting is drawn from an idea of Jacopo's, exemplified by a sketch from his London notebook); the scene has a motionless essentiality. However, beyond the highly forced lines (still not even approaching the urgency of Mantegna's style) the dramatic way in which the two painters approach the subject is different: Mantegna's harsh and embossed in the dark contrast of strong colours; Bellini's more subtly lyrical and humanly resigned.

A direct comparison between the two characters is made startlingly clear by the two *Presentations at the Temple*, executed by Bellini and Mantegna. The two
13 paintings, now housed respectively at the Galleria Querini Stampalia in Venice and the Staatliche
14 Museen in Berlin, have an identical structure and the same characters: in the foreground, leaning against a marble ledge, the Virgin is holding the swaddled Child, while the old priest stretches out to take it. At the sides and in the centre are several characters identified as Jacopo Bellini (the old man in the middle) and as Nicolosia and Andrea Mantegna, possibly recently married (the young couple standing at the sides facing left). In the painting by Bellini there are two more figures, identified by critics as the mother Anna and
15 Giovanni himself. The invention was probably Mantegna's, as can be assumed from the inflexibly austere framing of the scene, the Child of Donatellian inspiration which placed on the ledge becomes a unit of measure for the scene's spatial depth, and even the physical features of the priest, resembling Squarcione's prototypes which had been familiar to Mantegna.

Mantegna's *Presentation* is enclosed ineluctably within a square frame, a fatal screen separating the group from the spectator; the figures are absorbed in an incisiveness that renders them detached and eternal in an absolute vision. In contrast with its architectural solidity and marmoreal rigour, Bellini's scene has a quite different rhythm, with modifications that are apparently insignificant but in reality substantial: the addition of two characters gives the group more life, splits it up and reassembles it into a small human crowd. The elimination of the frame, or rather its reduction to a pale, marbled shelf, somewhat akin to a church altar-

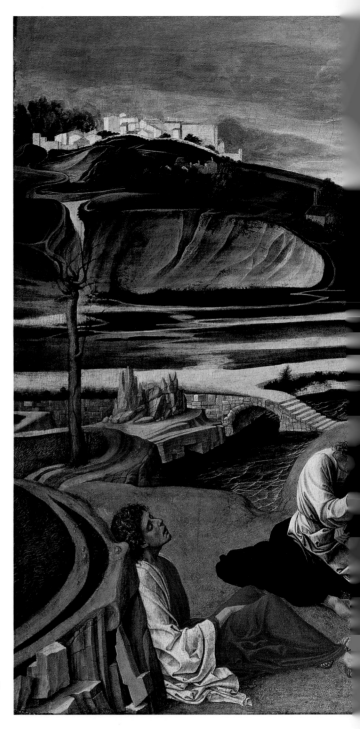

11. Agony in the Garden
81 x 127 cm
London, National Gallery

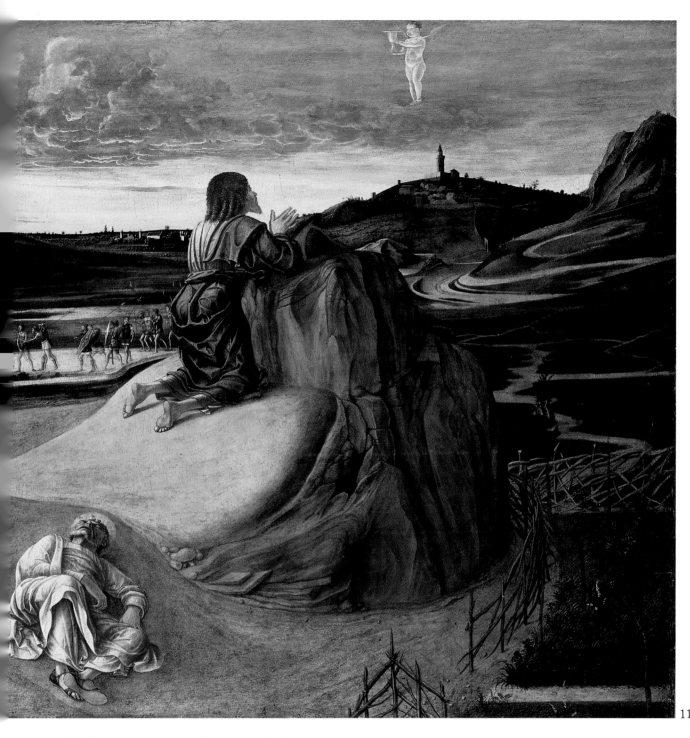

top, suddenly removes every barrier and draws one toward the scene with a sense of intimacy. To the solid as rock colours of Mantegna, who blends flesh-tones, stones and drapery, he responds with a pure and orchestrated play of whites and reds in clear alternation.

The views of critics about when the two works were painted do not concur, but it seems impossible to imagine that a long period of time separated their respective execution, as had been initially suggested, also by virtue of the diverse opinions regarding the precedence of the conception. It would be illuminating perhaps to discover the reasons that led to their execution, which do not appear to be a matter of chance, but almost certainly linked to family events, which with

this important family portrait were solemnized.

In 1648 Ridolfi mentioned a "Portrait of the Saviour" in the Agostinian convent of Santo Stefano in Venice. With the exception of Morassi, who believes that this portrait is the one now in a Swiss private collection, datable to around 1500, the painting seen by Ridolfi is usually identified with the *Christ Blessing* now at the 16 Louvre in Paris, a painting executed shortly after 1460. On the one hand the Louvre *Christ* is still associated with the master's first works, marked by a pathetic resentment that would soon disappear to leave space for an elevated "classical" melancholy; on the other, Bellini demonstrates his capacity to juxtapose the suggestions of Mantegna's style and those ge-

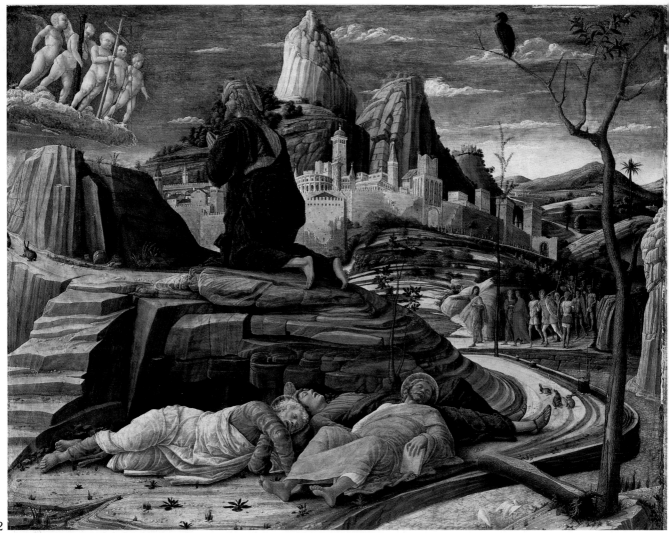

12

12. Andrea Mantegna
Agony in the Garden
London, National Gallery

nerically Paduan post-Donatello influences with a concept of light that is not only extraordinary but emphatically personal. It is the light, in fact, impregnating the clouds with dark, forbidding streaks which determines its incumbent psychological impact; it is the light also that fully invests the figure of Christ, and dictates its double charisma of human grief and divine symbolism, fixing it, like a revelation, in an eternal glow.

17 This first peak of independent poetic assertion was followed, shortly after, by the splendid Brera *Pietà* (Milan), one of the artist's most complete and programmatical figurative works. On the parapet on which Christ is held by the Madonna and St John is the inscription: HAEC FERE QUUM GEMITUS TURGENTIA LUMINA PROMANT: BELLINI POTERAT FLERE IOANNIS OPUS (When these swelling eyes evoke groans, this work of Giovanni Bellini could shed tears). This is the fragment of a hymn from the first book of Propertius's *Elegies*, whose presence at the base of the painting affirms the artist's religious educa-

tion. The figures stand out against a leaden, dreamlike sky. On the one hand the painting retains a strong Paduan element that is evident in the contours, adjusting gestures and figures to the strong expressive requirements of the drama. The silent exchange of emotions in the faces is reflected in the masterly play of the hands. The landscape behind them, empty and metallic in the cold, shining greys of the painful dawn of rebirth, accentuates the sense of the scene's anguish. Both the Donatello of the altar of St Anthony of Padua and, once again, Mantegna and the Flemish masters are the influences which spurred Bellini along the path of a sad and bitter pathos.

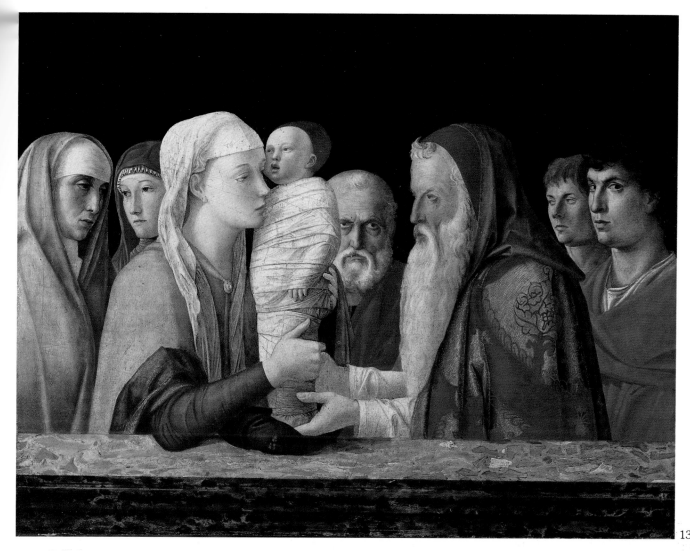

13

13. Presentation at the
Temple
80 x 105 cm
Venice, Galleria Querini
Stampalia

14. Andrea Mantegna
Presentation at the
Temple
Berlin-Dahlem,
Gemäldegalerie

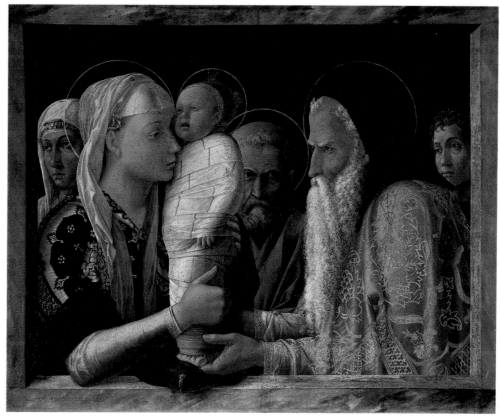

14

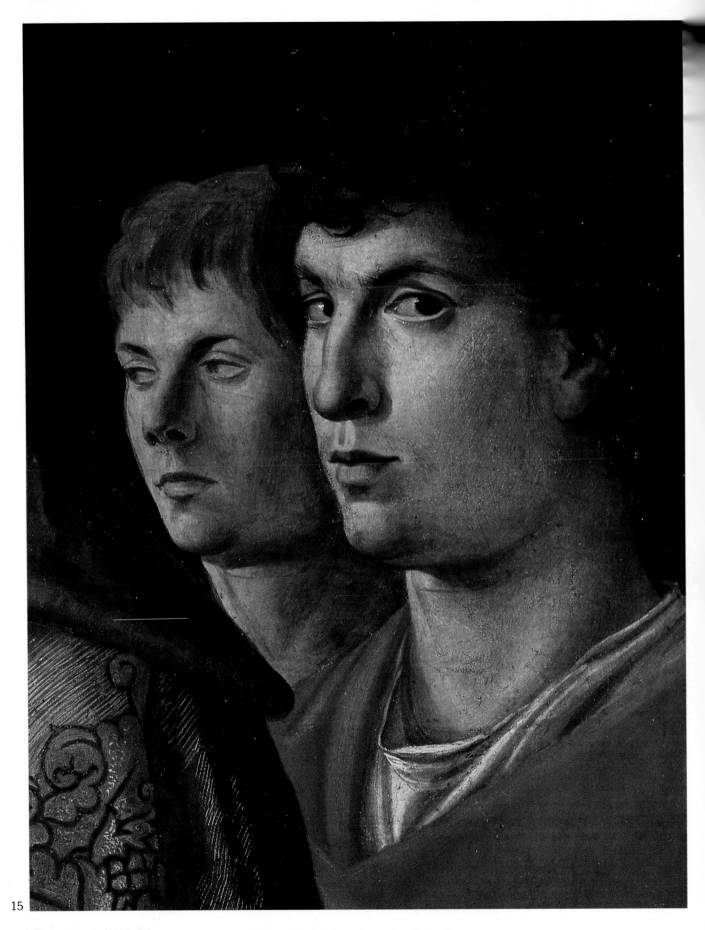

15

15. Presentation at the Temple
Detail of the presumed portraits of Giovanni Bellini and Andrea Mantegna
Venice, Galleria Querini Stampalia

16. *Christ Blessing*
58 x 44 cm
Paris, Louvre

17, 18. *Pietà*
86 x 107 cm
Milan, Brera Gallery

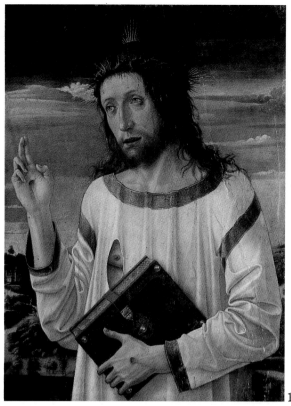

16

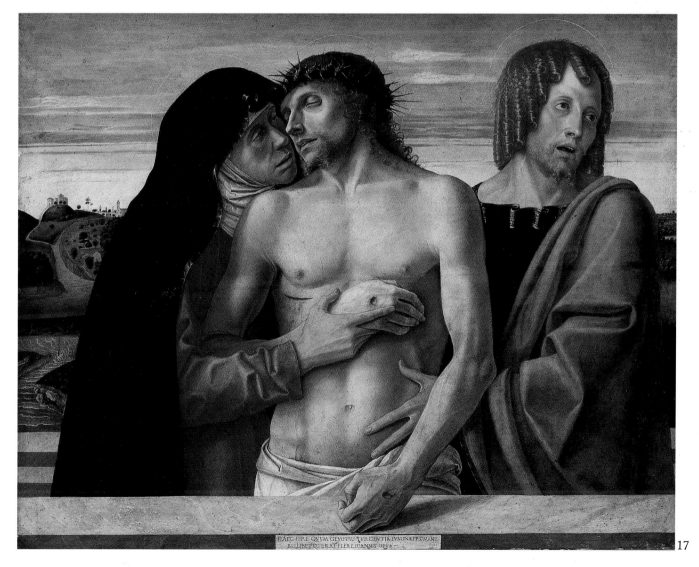

17

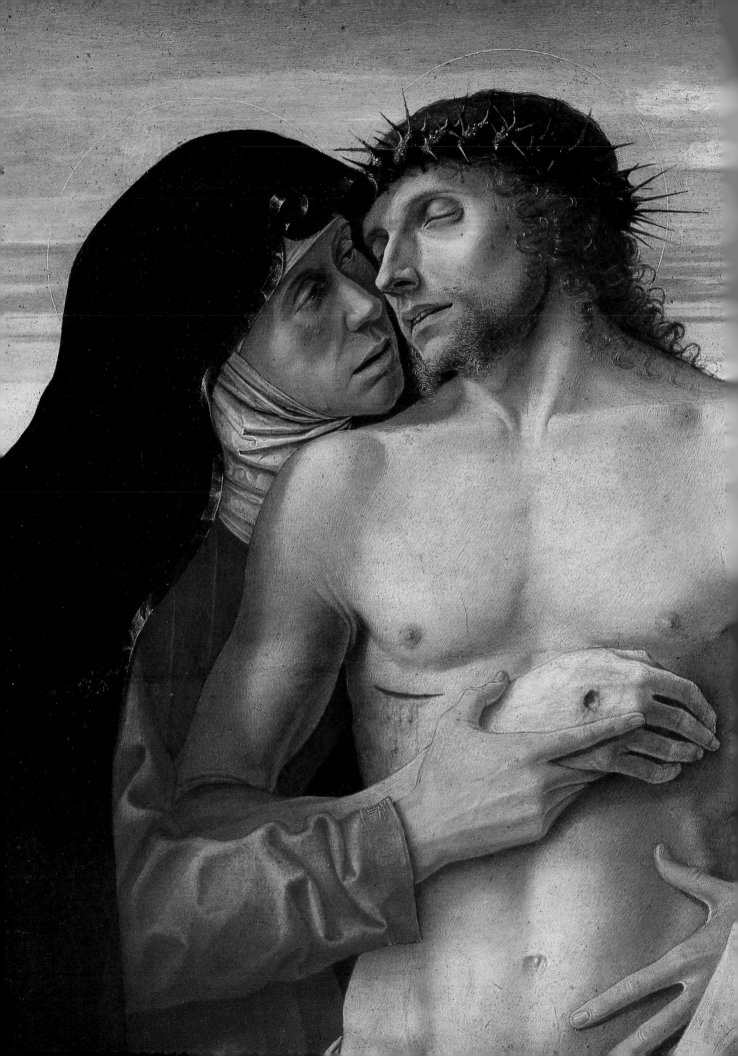

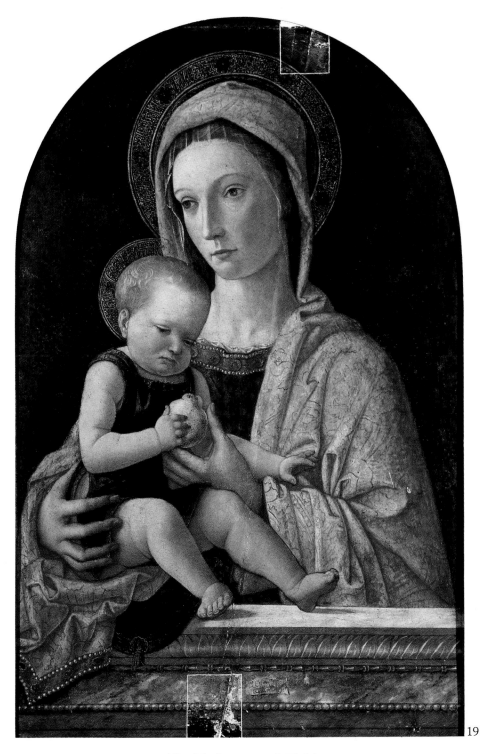

19

19. Madonna and Child
78 x 54 cm
Milan, Castello Sforzesco

The painting of Bellini's mature years

Around the middle of the Quattrocento the Venetian church of Santa Maria della Carità was rebuilt. Bellini was involved in the execution of four large triptychs, which were to be set up above four noble altars, built between 1460 and 1464. The works (Triptych of St Lawrence, Triptych of St Sebastian, Triptych of the Madonna and Triptych of the Nativity), dismantled and reassembled in the Napoleonic period when they entered the Galleries of the Venice Accademia (where they still are), with the traditional attribution to Bartolomeo and Alvise Vivarini, are an interesting episode in comprehending and studying Bellini's activity during these years, even if a large part of their execution is to be assigned to other artists, and the general planning was probably the responsability of Jacopo, and not Giovanni, who was only a partial executor. The polyptychs, particularly the one with St Sebastian, which is considered the best and most autographed of the four, constitute however a kind of dress-rehearsal for Bellini's first important public as-

20 signment: the polyptych of St Vincent Ferrer, executed for the altar dedicated to the saint in the Venetian basilica of St John and St Paul.

The polyptych comprises nine panels arranged in three parts: above, the Pietà with the Virgin and the Angel of the Annunciation at the sides; in the centre, the titular saint with St Christopher and St Sebastian at the sides; in the predella, five miracles of the saint

24 — St Vincent saves a drowned woman and brings back to life those buried under the ruins; St Vincent

26 consumes the flesh of a man and a woman guilty of a crime with the fire of the Word and saves their souls;

28 St Vincent brings a child back to life and frees the prisoners. Formerly the painting was crowned by a lunette with the Eternal Father, which was mentioned by Boschini (1664) and then lost. Champion of the Dominican Order, ardent and threatening preacher and controversialist, early confessor and later bitter adversary of Benedict XIII, the Spanish saint had been sanctified in 1455, and immediately the Order had committed itself to a vast campaign of propaganda and assertion of the cult. The construction of the altar is documented from January 1464: the relevant document, no longer traceable, but quoted by Fogolari in 1932, consisted of a receipt issued by a certain Olricus da Argentina to the then prior Giovanni da Merano "pro fabrica altaris Sancti Vincentii". The commissioning of the polyptych, and its commencement, would not therefore have been of a much later date. While most critics consider the miracles of the predella to be the result of a fairly substantial contribution by one of

Giovanni's assistants, Lauro Padovano, to whom Marc'Antonio Michiel (1521-48) attributed them, there is no doubt about the autography of the polyptych, which was reassigned to Bellini by Longhi, who took up Sansovini's old attribution of 1581. Certain discrepancies between the panels had initially led to the theory of an execution in two phases, separated by an interval of some time (Van Marle, Gronau). Although this theory is now known to be groundless, it serves to demonstrate how an apparent disorientation may be produced by the unusual and accentuated plasticity of some figures, particularly the saints of the central register. Their looming figures, furrowed by the lines of their bodies and drapery, are emphasized by a brilliant light shining from below. The measure of their perspective is expressed by one or two basic elements: the arrows of St Sebastian; the stout staff of St Christopher in the foreground. Above, the Christ in *pietà* (which, as always, faithfully follows a Byzantine iconographical model) is enclosed between an announcing angel and a Madonna with extremely limpid colours; in the angel, especially, the colours are blended with an almost glassy quality and their pallid and alabastrine splendour contrasts with the sudden blaze of the red curtain behind the Virgin. Here too the space is suggested by small details in an almost unnoticed and yet essential way: the deep dark folds of the curtain, and the sharp cold corner of the marmoreal pillar.

The same refulgent brightness and profiles strained into vigorous, dramatic gestures returns in the *Head of the Baptist* (Pesaro, Musei Civici) and in other works, like the *Dead Christ Supported by two Angels* (Berlin, Staatliche Museen).

This tendency would continue maturing towards the 1470s in a softer and more moving way, and culminate in the *Pesaro Altarpiece* depicting the *Coronation of the Virgin*, one of the artist's masterpieces and a pivotal work of his mature years. The painting does lack a precise chronological reference, and about this, and the closely linked and equally unresolved question of its commissioning, critics are particularly intransigent, arriving at controversial and far from conclusive results. The first datings (Fry, Cavalcaselle, Frizzoni) suggested that the altarpiece was executed around 1481. The date was initially brought forward by Longhi (1914), who was inclined to place it around 1465-

20. Polyptych of St Vincent Ferrer
Venice, Basilica of St John and St Paul

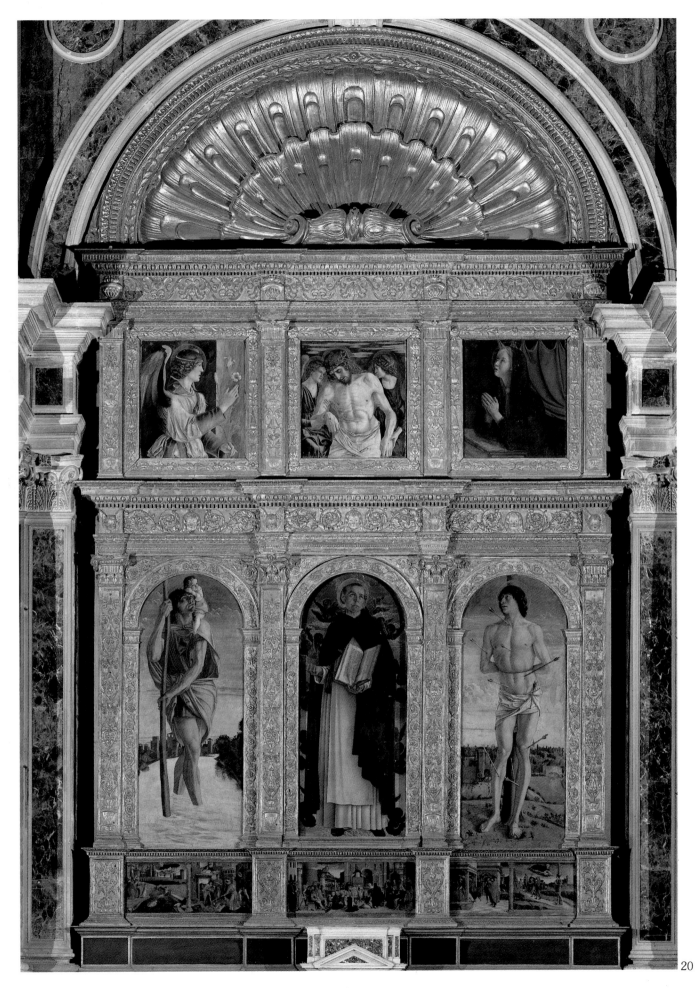

70; subsequently (1927), Longhi opted for an intermediary dating, around 1475, which was accepted by the majority of succeeding critics. Pallucchini (1959) and Meiss (1963), on the other hand, proposed the years 1470-71, basing their theory on the observation that the central part of the *Coronation of the Virgin* was echoed in a strikingly similar way in a work by Marco Zoppo, dated 1471 (*the Madonna and Child with Saints* painted for the Order of the Observants of Pesaro, now in Berlin). However, neither is this a convincing argument, given that Marco Zoppo might have conceived his altarpiece before Bellini (this is in fact what recent critics have assumed), and in any case the admittedly unquestionable iconographical similarities between the two works are invested with values and meanings that are so different as to render this kinship completely marginal. The altarpiece by Bellini certainly has also a politico-religious value which is impressed in and in some way determines the composition. On the one hand it celebrates the profession of Franciscan faith (an Order linked to the Sforza family, then lords of Pesaro, by strong bonds of devotion and protection) through the presence, at the sides of the throne and in the left and right-hand pilasters, of saints whose cult was particularly venerated and fostered by the friars in Pesaro and in the territory of the *signoria*. But, on the other hand, they are particularly significant by virtue of a symbolic meaning attributed to their presence: George, the knightly saint so dear to the noble courts, and Terence, saint of Pesaro represented as an ancient *miles*, occupy the compartments at the base of the pilasters, where heraldic insignia were usually placed, and thus represent the civil and military power of the Sforza. Behind Terence, on the left, a Roman memorial tablet with a bust and an inscription extolling the emperor Augustus completes the celebratory reference to the *potestas* of the ducal family.

The afore-mentioned are only the main theories, and are accompanied by further hypotheses which have emerged from the interpretation of other elements present in the altarpiece, such as the castles represented in various parts. A widely accepted argument is the one advanced by Everett Fahy, who in the fortress model in the hands of St Terence (on the right-hand pilaster, below) recognized the Fortezza Costanza, designed by Laurana for Costanzo Sforza, lord of Pesaro, in 1474 and finished in 1479. Obviously, this cannot lead to a dating of the altarpiece after this time, since in 1475 Enzola had already reproduced the image of the fortress on the back of a medallion dedicated to Costanzo, and had evidently had the opportunity to examine the designs for it well before work on it had begun. Consequently, the same possibility might well have existed for Giovanni Bellini, though in this case also it must be emphasized that there are dis-

crepancies between Bellini's model and the real fortress, and there therefore exists a margin of uncertainty in Fahy's theory. Besides, the fortress depicted in the hands of Terence need not necessarily be a real one: it might be a more generic image, represented to indicate metaphorically the importance of the Sforzesque fortifications and the saint's protection over them, just as the castle depicted behind the Coronation could be Gradara — as will be shown — even though it is primarily an emblem of ducal power.

As far as the dating to the 1480s is concerned, finally, various scholars have reached an agreement (Battisti, Castelli) on the basis of certain iconographical considerations. In Castelli's view the altarpiece may represent the Papacy's legitimization of the regency of Camilla of Aragon, which began in 1483. In Battisti's opinion, on the other hand, the humility represented in the bashful Madonna finishes by prevailing over the regality of Christ, and in this we may recognize an allusion to the vehement contemporary theological debate between Franciscans and Dominicans. The many-towered landscape framed by the throne can also be explained as a complex symbology of the Madonna — Virgin (the arid Earth) and Mother (the fertile land) — protectress of the faithful (the fortress).

The occasion for the execution of the altarpiece is also a matter of uncertainty and controversy. According to Vaccaj (1909) it might have been ordered to celebrate the taking of Gradara, the Riminese fortress conquered by Pesaro in 1463: the many-towered and fortified landscape in the background of the Coronation would in this case refer to the representation of Gradara. Alternatively, we might consider the marriage between the lord of Pesaro and Camilla of Aragon in 1474. This second theory at least has the merit of corresponding to the only archival evidence that might refer to Bellini's work: the will of the painter Giovanni Pizzamegli, who in 1476 left a small offering as "solvatur pretium" for the panel of the high altar of the church of St Francis (Valassi, 1988). If this painting was, as is reasonable to assume, the one by Bellini, it means that by this date it must have been, if not already finished, at least in an advanced state of planning. Other far from insubstantial considerations of a different nature have some weight in favour of a dating to the second half of the 1470s. Firstly, the execution of the painting in oils involves the knowledge by Bellini of a technique that Antonello da Messina introduced definitively in Venice; he arrived in the city in 1475. Before this time the use of oil-based binders, although already known about insofar as they were adopted by Flemish painters, was fairly unusual among Italian artists. Indeed, Bellini always showed himself to be technically highly advanced, to such an extent that in the *Pesaro Altarpiece*, he reached the point of combining traditional blue pigments (azurite

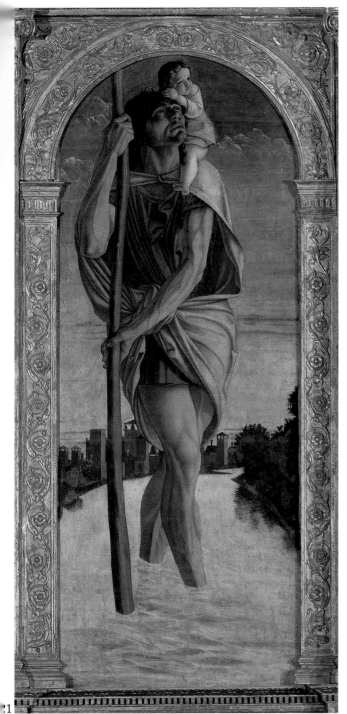

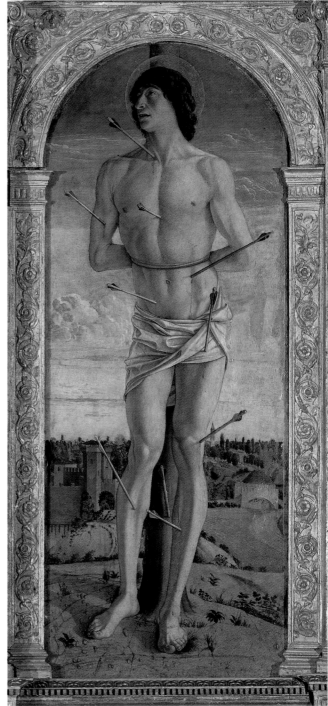

21. *Polyptych of St Vincent Ferrer*
Detail of St Christopher; 167 x 67 cm
Venice, Basilica of St John and St Paul

22. *Polyptych of St Vincent Ferrer*
Detail of St Sebastian; 167 x 67 cm
Venice, Basilica of St John and St Paul

and lapis-lazuli) with enamel blue pigment twenty years in advance of Leonardo who, having used it in 1492 in the Milanese apartments of Ludovico il Moro, was until recently considered the first documented case in Italy of the use in painting of a technique belonging to the glass industry (Bianchetti, Laurenzi Tabasso, Mariottini, 1988). Venetian painting would make frequent use of enamel from the Cinquecento onwards: evidently we must acknowledge in Bellini a level of accomplishment which enabled him to experiment, or intuit ahead of his time, techniques and possibilities hitherto disregarded.

Stylistically, the *Pesaro Altarpiece* marks the achie-

25

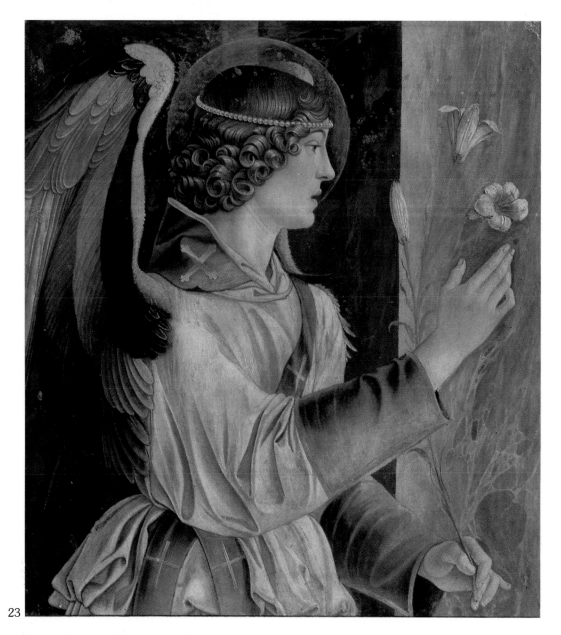

23. *Polyptych of St Vincent Ferrer*
Detail of the Angel; 72 x 67 cm
Venice, Basilica of St John and St Paul

24. *Polyptych of St Vincent Ferrer*
Detail of the predella: St Vincent saves a drowned woman and brings the dead back to life; 36 x 60 cm
Venice, Basilica of St John and St Paul

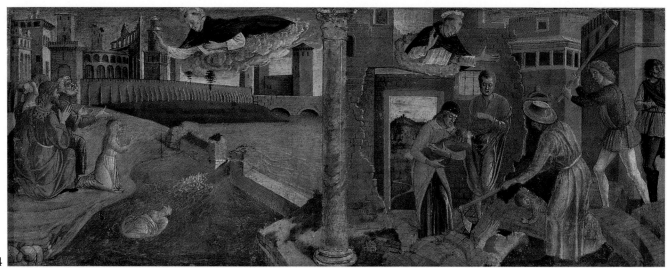

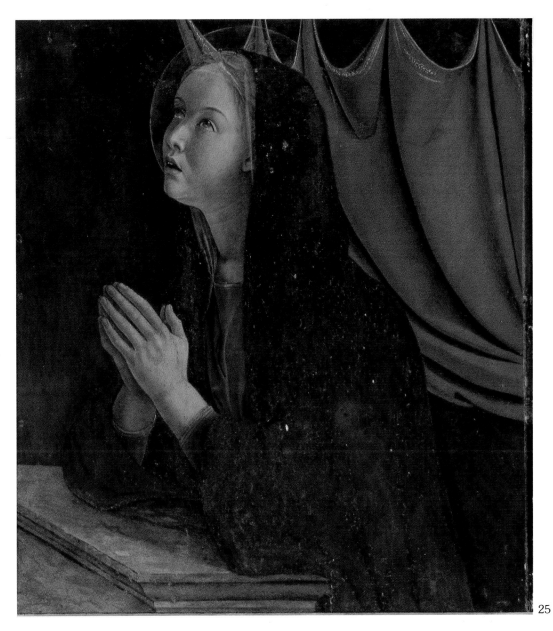

25

25. *Polyptych of St Vincent Ferrer*
Detail of the Virgin; 72 x 67 cm
Venice, Basilica of St John and St Paul

26. *Polyptych of St Vincent Ferrer*
Detail of the predella: St Vincent brings two dead
persons back to life; 36 x 60 cm
Venice, Basilica of St John and St Paul

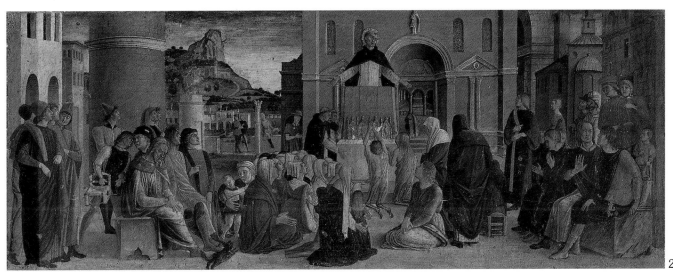

26

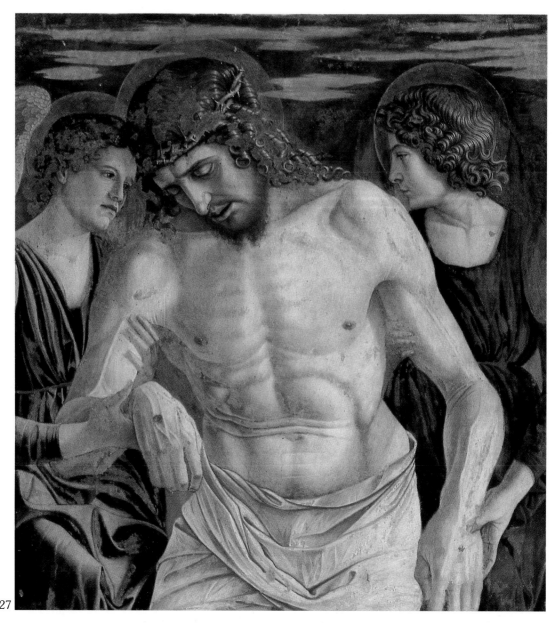

27

27. *Polyptych of St Vincent Ferrer*
Detail of the Pietà; 72 x 67 cm
Venice, Basilica of St John and St Paul

28. *Polyptych of St Vincent Ferrer*
Detail of the predella: St Vincent brings a child
back to life and frees the prisoners; 36 x 60 cm
Venice, Basilica of St John and St Paul

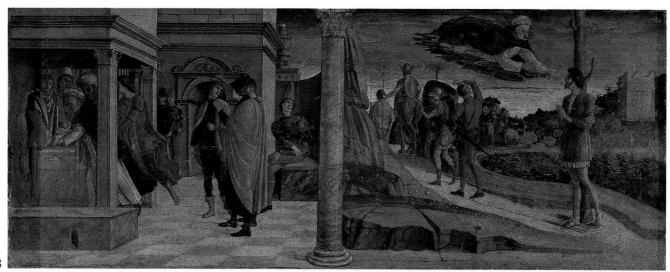

28

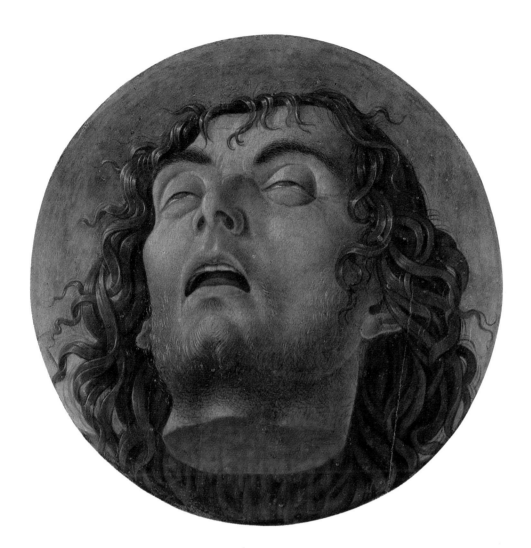

29. Head of the Baptist
diam. 28 cm
Pesaro, Musei Civici

vement of a new balance. The lesson of Mantegna appears to have been sublimated in the light of that of Piero della Francesca, thus opening the way to yet another issue: where and when, in other words, had Bellini been able to contemplate and become so well acquainted with the art of Piero della Francesca. Probably the *Pesaro Altarpiece* itself constituted for him the occasion of a journey from Venice to the Marches, which was among other things his mother's birthplace, and therefore the possibility of a direct appreciation of the works of Piero della Francesca.

The typically Venetian architecture of the altarpiece recalls that of some contemporary funerary monuments, primarily that of the Doge Pasquale Malipiero, erected by Pietro Lombardo in the church of St John and St Paul. However, the typology of a frame that is integral with the painting, in the interests of an inseparable perspective and spatial continuity, is fundamentally new (even if it drew on various precedents, such as Mantegna's *San Zeno Polyptych*). The idea of the throne's open back-piece, a veritable paint-

ing within a painting, serves precisely to resume and further articulate this new structural and compositional definition. In the great altarpiece that followed, that of San Giobbe (ca. 1487) and in the altarpieces to come, 40 this intuition would develop and mature until it reached a total, and also optical, indivisibility of the painting from its frame, which constitutes the only real access to it, the starting point of the vision itself.

The *Coronation* remained in the church of San Francesco at the time of its dissolution in 1797, then became the property of the Comune, and after various vicissitudes ended up at the Musei Civici in Pesaro, where it is now. The *Pietà*, which according to cus- 37 tomary canons of the time crowned it, had a different history. At the time of the church's dissolution, it went to Paris; it was recovered and brought to Rome by Canova in 1815; it finally came to the Vatican Pinacoteca, where it was given various different attributions (Bartolomeo Montagna, Giovanni Buonconsiglio, Andrea Mantegna) and it is to be found there still. From Frizzoni (1913) onwards (though Giulio Vaccaj had already intuited it in 1909) it has always been considered the original cymatium of the *Coronation*, replaced in the 18th century by a painting of St Jerome. The only dissenting voice has been the very recent one of Ileana Chiappini di Sorio (1988), who

raises variously weighted objections to this now traditional interpretation: the diversity of the decorative parts of the respective frames; the difference in style (Pier-Francescan that of the *Coronation*, Antonellian that of the *Pietà*); the contradiction of, or rather the divergence from, the focal point; and the lack of connection between the two geometric entities constituted by the paintings. Chiappini's conclusion is that the *Pietà* was probably not painted by Bellini to be arranged on this altarpiece, and possibly became its crowning piece only some years after the execution of the latter. The *Pietà*, however, is a sublime artistic subject in itself. The "extraordinary finish", which Vasari mentions as belonging to the Pesaro altarpiece, seems to refer to its extraordinary purity of line. If, in its very essence, the *Coronation* appears balanced, theologically calibrated, and singularly devoid of any emotion, the *Pietà*, by contrast, seems to have concentrated a deeply-felt knowledge of the divine sacrifice. The choral silence of the three figures around Christ, their contemplative meditation, and the play of their interlocking hands, render its sacramental sense of sublime communion.

The arrival of Antonello da Messina in Venice marked a significant turning-point in the development of Venetian art in the second half of the 15th century. In addition to his famous portraits, which were already known in Venice and provided a fundamental example to local artists, in the Serenissima, on the commission of Pietro Bon, Antonello left a large altarpiece for the church of San Cassiano, which made a profound impression on his Venetian contemporaries. The altarpiece, which has survived in an extremely fragmentary condition (Vienna, Kunsthistorisches Museum), represented an enthroned Madonna and Child surrounded by eight saints. A strong Flemish naturalism was accompanied by a wholly Italian sense of form and its geometric rigour, resulting in a rational and lucidly sculpted sharpness that was quite new in Venice. As far as Bellini was concerned, however, the exchange was not only "one way", since he himself was to exert some influence on Antonello with his compositions.

The innovativeness of the Sicilian painter, which had already been partly assimilated by Bellini in the *Pesaro Altarpiece*, reached its maturity, and at the same time received a complete and independent reply, in the altarpiece with the *Madonna Enthroned with Child and six Saints*. This painting was executed around 1480 for the new church of San Giobbe, originally over the second altar on the right of the church, completing in an illusory way, with its own spatiality, the Lombardian architectural plan. When it appeared, it immediately became one of Bellini's most celebrated works, so much so indeed that it was at once included in Sabellico's treatise *De Urbe Situ*, datable to between 1487 and 1491. Sabellico actually mentions it as one of the

first works executed by Bellini, which has given rise to much debate about its actual chronological placing. With the exception of Coletti, however, who takes it as far back as 1470-75, the most frequently proposed datations range from between 1480 and 1500. Bearing in mind that the altarpiece was painted in oil and that Antonello da Messina's *San Cassiano Altarpiece* dates to 1476, it seems likely that it was executed in the period 1480-85. This datation could be moved back slightly if we were to accept Sansovino's proposition (1581) that this was the first altarpiece painted by Bellini with this very technique that Antonello da Messina introduced in Venice in 1475-76. Unfortunately, the loss of the Ducal Palace's *teleri* (large canvases), in whose execution Giovanni had substituted Gentile in 1479 when the latter had left for Constantinople with a diplomatic delegation, prevents convincing comparisons with the great works of those years.

The *San Giobbe Altarpiece* is, however, one of the cornerstones of the artist's mature years. A coffered vault is a perspective introduction to the composition, which is supported at the sides by pillars similar to the real sculpted ones of the altar. The pillars flank a deep niche, which with its shady penumbra amplifies the space behind the holy group. As in the *Pesaro Altarpiece*, and developing the premises of the altarpiece of St John and St Paul in Venice, Bellini therefore conceived the painting as a coherent prolungation of the real space.

In it, the figures are arranged with redoubled monumentality and human warmth; the modelling is softened by the refined blending of colours, which reflects dim crepuscular lights from the apsidal basin, depicted like a gold mosaic according to a visual and chromatic tradition associated with the basilical mosaics of San Marco. The Madonna, as usual absorbed in her majesty, holds a Child that is very similar to the blessing Child of the *Madonna Contarini* (also from the Accademia), while the Byzantine inheritance, which is still present like an unfathomable legacy in Bellini's painting, makes it mysterious and unattainable, closed in an iconical detachment.

The *Madonna and Child* of the Accademia Carrara in Bergamo must be dated after 1483. The painting, which has been in Bergamo since the 16th century, probably formed part of the dowry of the Carmelite nun Lucrezia Agliardi Vertova, abbess of the Sant'Anna monastery at Albino. On the parapet in front of the Virgin, a detail present in many other similar compositions, there is a fruit. Like the walled and many-towered city on the right, and the inlet on the left, it is a symbol referring to the Virgin, according to the attributes assigned to her by hymns, analects and lauds ever since the Middle Ages. As Battisti has shown, in these sacred and devotional texts, artists had a vast repertoire of figure images from which they drew in-

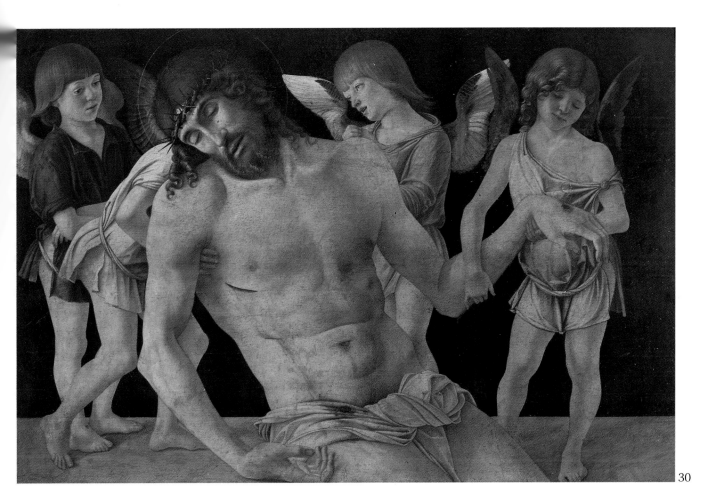

30. Dead Christ Supported by Angels
91 x 131 cm
Rimini, Pinacoteca Comunale

spiration to build or symbolically accompany the divine figure. In this respect too, Bellini's rich humanistic culture allowed him a continuous evolution, and eventually brought him to a play of metaphorical references that were so subtle and natural as to make us lose sense of them. It is understood that he was led to attain this result mainly through a fervid talent for poetry, which forced him to address the creator and created, the natural and the divine, and the inner world and the world outside with the same emotional involvement.

The *Carrara Madonna* is one of the clearest expressions of this shadowless piety. The mother and child are linked, more than by the tender embracing gesture, by the rapt, reflective gaze with which the Madonna engulfs her son. The painting is the prototype from which various similar compositions derive, such as the *Madonna and Red Angels* of the Accademia in Venice, with the child seated on the Virgin's left knee.

For this reason too, as with the cleanness of the plasticity with which the image is built, it must certainly be considered as pre-dating the *Madonna degli Alberetti*, dated 1487 at the base of the ledge on which, as usual, the Child appears. In its turn, this highly balanced painting incorporates a system of double lighting that characterizes a small group of similar compositions. Indeed, the curtain behind the Virgin cap-

42

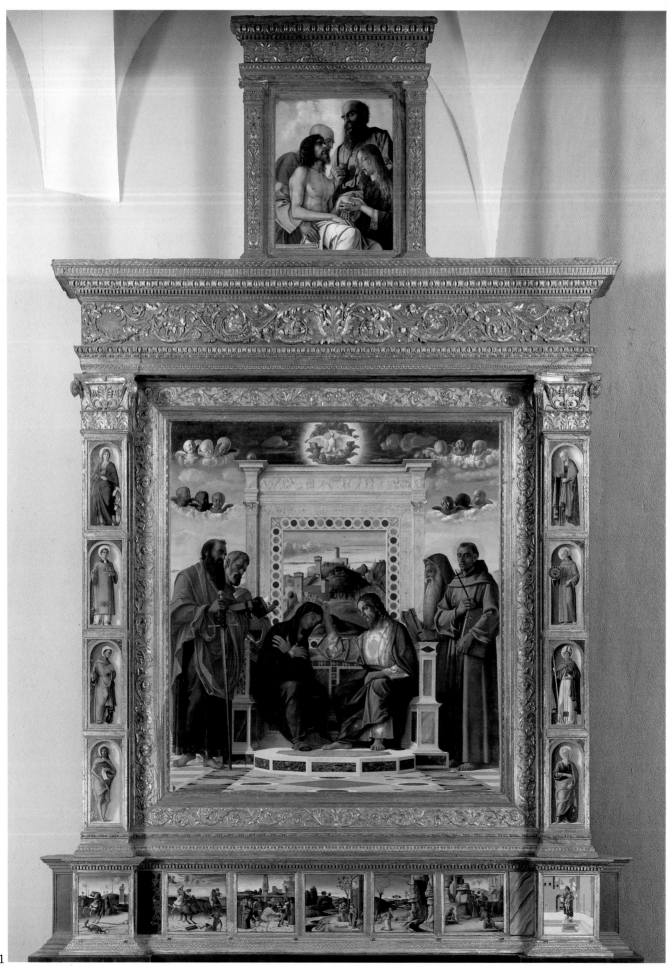

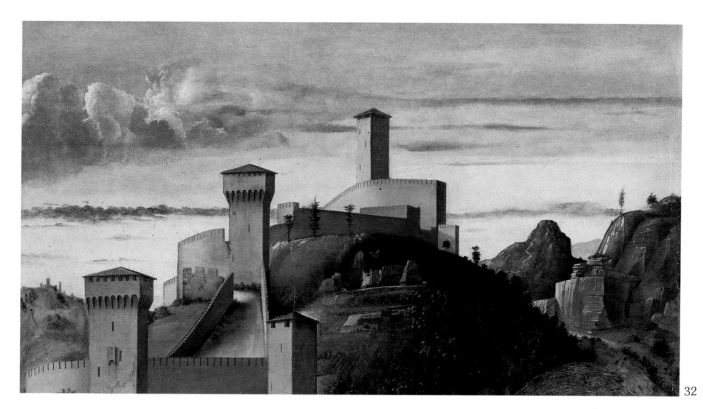

32

31. *Pesaro Altarpiece*
(photomontage with the Pietà now in the Vatican
Pinacoteca)
Central panel 262 x 240 cm
Pesaro, Musei Civici

32. *Pesaro Altarpiece, detail*
Pesaro, Musei Civici

33. *Pesaro Altarpiece*
Detail of the predella: St George and the Dragon
40 x 36 cm
Pesaro, Musei Civici

34. *Pesaro Altarpiece*
Detail of the predella: St Terence
40 x 36 cm
Pesaro, Musei Civici

tures the light coming from in front of her in such a way that the shadow of her figure is projected onto the fabric. In the landscape background beyond, on the other hand, the light expands totally independently in an even, diffused luminosity.

The triptych of the Venetian church of the Frari, 3 comprising large sections portraying the *Madonna and Child Enthroned* (in the centre), *Saints Nicholas and Peter* (on the left) and *Saints Mark and Benedict* (on the right) is signed and dated 1488 on the central panel. This generally accepted datation has been questioned by Fry, who chooses to interpret this as the final date of a work begun some years earlier in 1485.

The painting's wooden frame, probably designed by Bellini himself, is again in perfect spatial harmony with the painting. Its pilaster strips, in fact, illusorily support the ceiling of the open space at the sides in which the saints are placed. In the centre the Virgin, raised aloft by the throne, has a lighted golden apsidiole behind her which recreates the same effect and sense of spatial unity as that in the *San Giobbe Altarpiece*. On the 40 mosaic that covers it a Latin invocation can be read: IANUA CERTA POLI DUC MENTEM DIRIGE VITAM: QUAE PERAGAM COMMISSA TUAE SINT OMNIA CURAE (Secure gateway to Heaven, guide my mind, lead my life, may everything I do be entrusted to your care).

Although apparently more "archaic" in that it once again follows a polyptychal scheme (possibly on the request of the commissioner), in many respects the painting of the Frari actually constitutes a further evolution of the *San Giobbe Altarpiece*, of which it is reminiscent in many ways. Extremely similar, for example, is the figure of the enthroned Virgin, immersed 45 in a fine golden dust that is contrasted only by the compact blue colour of the mantle, which in some way isolates her in space. But mostly it is the study of light that continues, in favour of which the merely plastic elements lose their importance, while the question of space, despite the limits imposed by the shape of the triptych, is ingeniously resolved, not only by rebuilding within the painting the unity interrupted by the frame, but also by suggesting at the sides a vast perspective depth by means of a thin strip of landscape.

The *Madonna and Child, St Mark, St Augustine and* 46 *the Kneeling Agostino Barbarigo* of San Pietro Martire

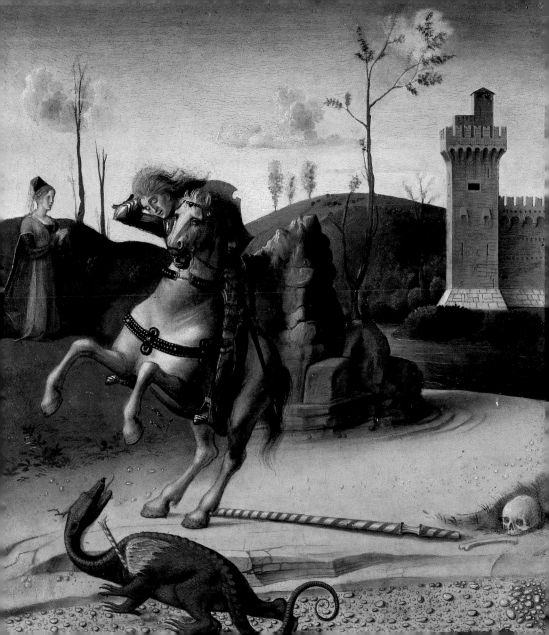

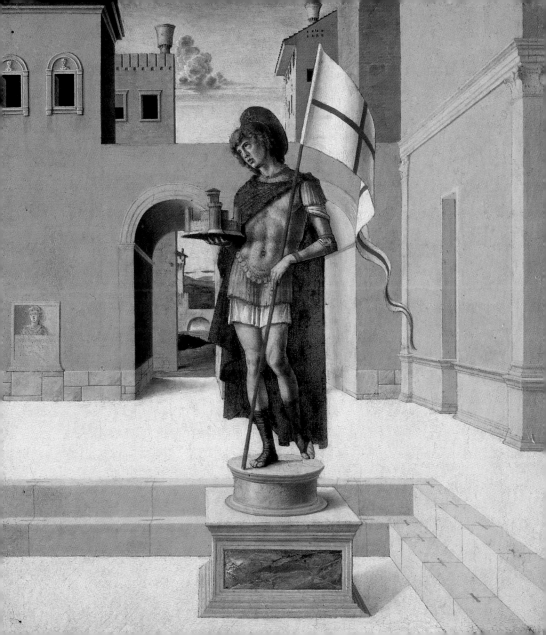

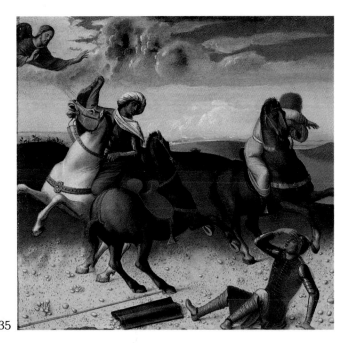

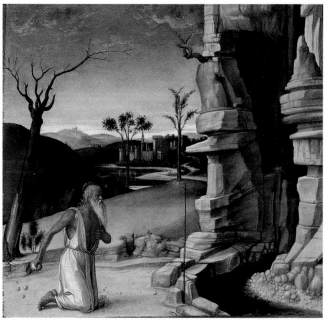

at Murano, one of the few chronologically undisputed points in Bellini's career, dates to 1488, the date written after the signature in the centre of the Virgin's throne. The first source concerning the altarpiece is the will of the person who commissioned it, Doge Agostino Barbarigo. Belonging to an important family of the Venetian aristocracy, Agostino, a unique case in the history of the Republic, had succeeded his elder brother Marco to the dogate, although the death of the latter, following a furious public argument between the two brothers over political differences, was seen by many as his responsibility. To demonstrate that he was the heir and loyal continuer of his brother's actions, in the first years of his office especially he had promoted a series of public artistic commissions (the Scala dei Giganti, entrusted to Marco and Pietro Lombardo, the Torre dell'Orologio of Mauro Codussi, the completion of the Ducal Palace with the building of the wing towards the Rio), aimed at a stately and hegemonic image of Venice, consonant with the political ideas which had been Marco's and which he had made his own. At the same time, in a private context, he was engaged in the erection of a grand funerary monument in Santa Maria della Carità for himself and his brother, commissioned Gentile Bellini with the official portrait of Marco for the series in the room of the Maggior Consiglio (a portrait that was executed between 1486 and 1487), and entrusted Giovanni Bellini with the task of painting a "pala granda" (large altarpiece), as a token of expiation for his moral debt, which he placed in the most prominent position of the main hall in the family palace. In the painting St Mark, with an expression of affectionate protection, presents the kneeling Agostino to the Virgin. According to the words of the Doge himself, both the background landscape and the walled fortress on the right (similar to

35. Pesaro Altarpiece
Detail of the predella: Conversion of St Paul
40 x 42 cm
Pesaro, Musei Civici

36. Pesaro Altarpiece
Detail of the predella: St Jerome in the Desert
40 x 42 cm
Pesaro, Musei Civici

the one in the *Pesaro Altarpiece* of some years before) 3 refer semiologically to Mary, "nostra avvochata appresso el nostro summo chreator Iddio" (our advocate to our divine creator God). The withered tree, on the other hand, a symbol of death and of guilt that must be expiated, refer to the Doge's family disgrace.

Dying in 1501, after a much-debated and variously evaluated dogate, Agostino left the canvas to the women's monastery of Santa Maria degli Angeli at Murano "because that figure of our Lady with angels is well suited to being placed above the high altar of her church…". And he added, "… And that neither our sons-in-law nor our daughters (Agostino had had five children, but the only son had died before him), nor our grand-children may put it in our great house, nor in any place other than above the high altar of that very pious monastery". Nonetheless, the canvas was soon moved to make space for an *Annunciation* commissioned to Titian.

But Vasari's information, surprisingly accepted by Pignatti (1969), that the altarpiece had been transferred to the Camaldolite church of San Michele in the 16th century, must be wrong. It is probable that Vasari confused two different works: the *Barbarigo Altarpiece* and a now lost altarpiece by Bellini that must

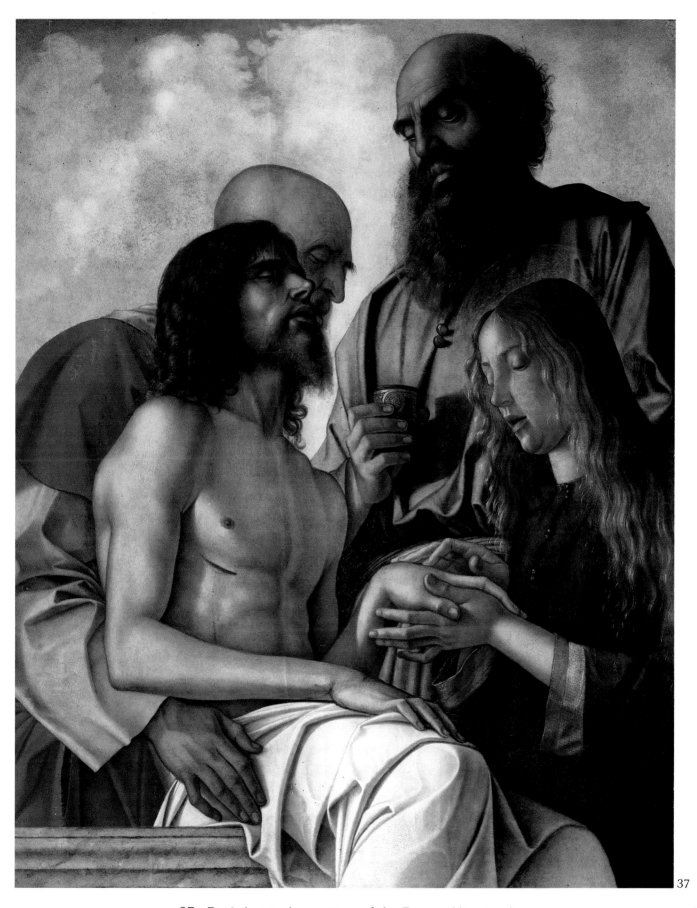

37. Pietà (original cymatium of the Pesaro Altarpiece)
106 x 84 cm
Rome, Vatican Pinacoteca

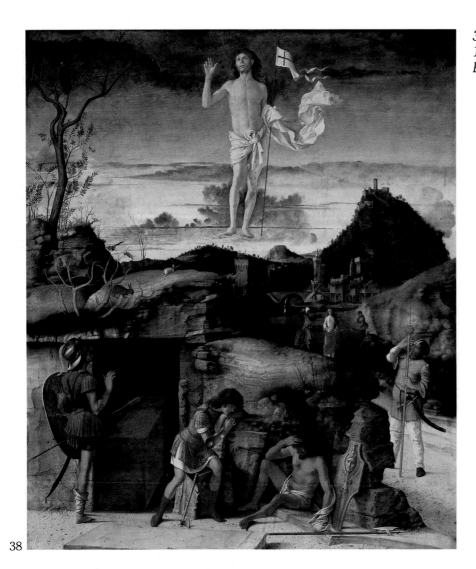

38

have been in the chapel of Santissima Croce in San Michele. The novelty of the painting, in which for the first time Bellini abandons the spatial conception of the Quattrocento in order to set forth a new relationship between nature and sacred conversation, brought forth a highly reductive judgement by Von Marle (1935). Generally regarded as a fundamental work, I would say that the canvas does in fact have numerous limitations that other critics, starting with Gronau (1930), have attributed to the interventions of assistants such as Marco Marziale. Hendy and Gold-scheineder (1945) went as far as to suggest that this painting was long ago transferred onto canvas, in 47 which the only autograph part was Barbarigo's ermine fur. The restoration carried out at the beginning of the 1980s invalidated these considerations, which in some cases were quite groundless, restoring the altarpiece to the perhaps not easy place it occupies in Bellini's career. Indeed, Rocco (1969) is not wrong in regarding this as Bellini's first attempted experiment in tonal painting, while acknowledging that its quality is profoundly different from Giorgione's, closely linked as this was to the theme of a profane lyricism, quite obviously absent here. Although bearing in mind what is

experimental in this work, the softening of the *materia* and its development into a mature picturesqueness, "the synthesis of figure, architecture and landscape into a new naturalistic language" (Merkel, 1983) in effect make the *Barbarigo Atarpiece* a crucial landmark in Bellini's career in relation to the *Frari Triptych* 4 too, which as we have said also dates to 1488, although the tripartition of the frame and a luministic concept still linked to problems of plasticity lead one to suppose it was conceived prior to this dogal altarfrontal.

Along the same lines is the *Sacred Conversation*, 4 formerly in the Renier Collection in Venice (now in the Accademia, Venice), one of the loftiest expressions of this theme. Compared to the other analogous and probably autograph version at the Prado in Madrid, this painting shows a magisterial development that has prompted critics to recall the fundamental teaching of Leonardo's *sfumato* (Gamba, 1937; Moschin, 1963). The light, in fact, softly progressing over the faces and garments, strikes from the side the assorted figures of the Virgin and Saints Catherine and Magdalene, silent companions of the former in sacred contemplation. Also in the characteristic symmetrical composition of

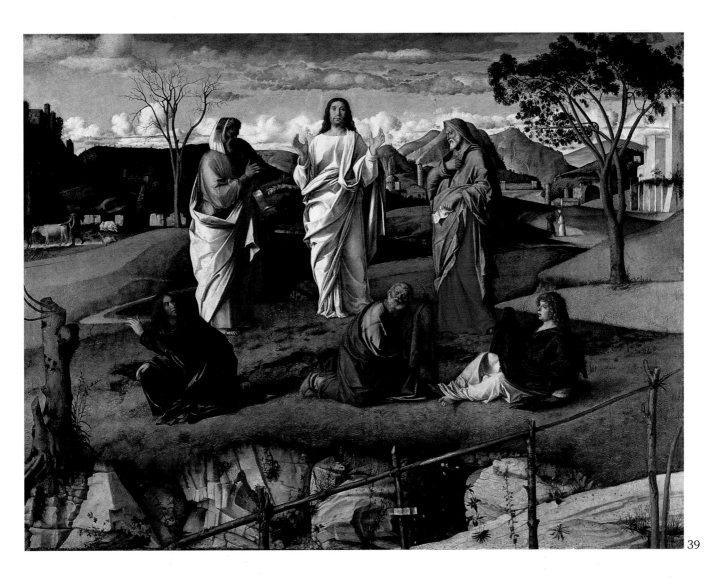

39. Transfiguration of Christ
115 x 151,5 cm
Naples, Galleria Nazionale di Capodimonte

all Bellini's sacred conversations, the spreading of a crepuscular and intimate light that tinges the figures is a demonstration of how far ahead Bellini was proceeding in these years in developing the concepts of space and colour which had belonged to Antonello da Messina. The indistinct background, completely lacking any kind of connotation, is just "opened" in depth by the two diagonal wings of the saints which close at the sides the perfect pyramid formed by the group of the Madonna and Child. What is suggested is a warm and yet transparent depth, in which the figures move without being engulfed.

The success of paintings like this can be measured by the large quantity of existing variants, mostly the work of the workshop or only partially autograph (*Madonna and Child with Saints John the Baptist and Anne — or Elisabeth — in Urbino, Galleria Nazionale; Madonna and Child with four Saints and the Donor*, New York, Pierpoint Morgan Library), and often reproduced in various copies.

In the context of these compositions we should also include some representations of the *Lamentation over the Dead Christ*, painted at the end of the 15th century, notable among them the rare chiaroscuro of the 50

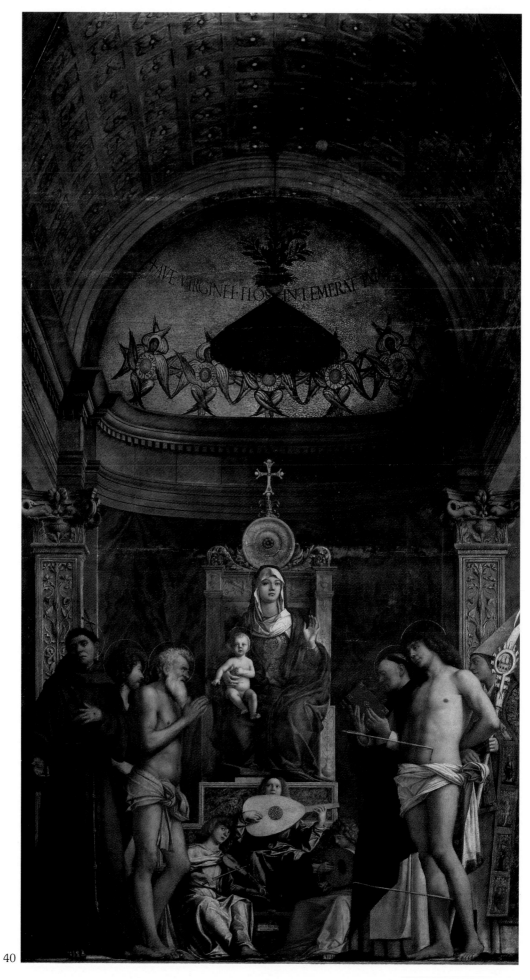

40

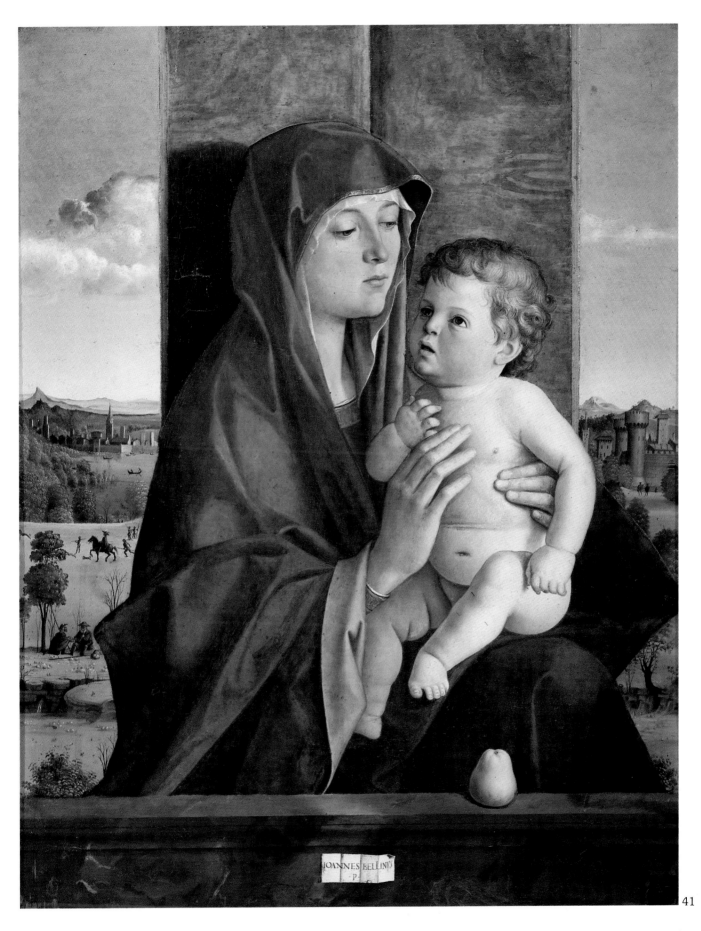

41

40. *San Giobbe Altarpiece*
471 x 258 cm
Venice, Accademia

41. *Madonna and Child*
83 x 66 cm
Bergamo, Accademia Carrara

41

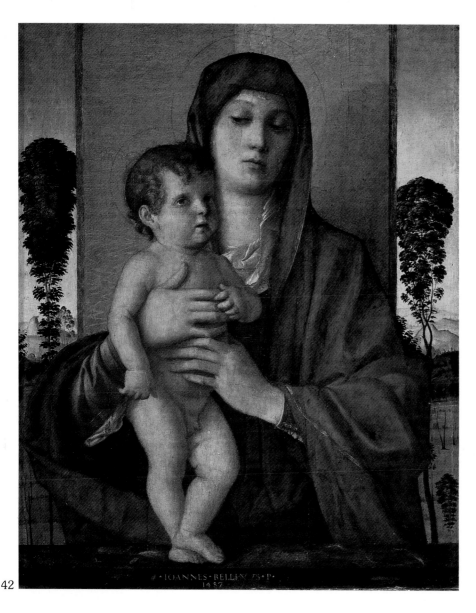

42

42. *Madonna degli Alberetti*
74 x 58 cm
Venice, Accademia

43. *Frari Triptych*
Central panel 184 x 79 cm
Venice, Church of the Frari

Uffizi Gallery in Florence, a gift made by Alvise Mocenigo to the Grand-duke of Tuscany. This is a more crowded composition than the previous *imago pietatis*, in which the very isolation of the figures becomes a diaphragm that separates the spectator from the drama. Here the prominent knees of Christ, and his abrupt foreshortening sharply break this ideal wall and bring the sacred group closer to, and therefore in more immediate communication with, those worshipping.

From the 1470s, and simultaneously with this intense sacred output, Bellini had been engaged in work as a portraitist (in fact the *Portrait of Jörg Fugger*, the first known dated work by Bellini, is of 1474); although not particularly prolific, this activity was highly significant in terms of its results. The influence of Antonello da Messina in this field was highly evident in some instances. The *Portrait of a Young Man in Red* of the National Gallery of Art in Washington (Mellon Collection), datable to between 1485 and 1490, is one of the clearest examples of this, even though

Shapley correctly notices that the psychological rapport between the person portrayed and the spectator is less immediate than in Antonello da Messina.

Although Antonello da Messina can still be considered as the main influence in the *Portrait of a Condottiere* of the National Gallery of Art in Washington, this is nonetheless divorced from the "types" of the Sicilian artist and it seems impossible to date it, as some critics have, to between 1482 and 1484. This datation derives from the widely accepted identification of the character with Jacopo Marcello, who was *capitano generale* of the Republic in those years, and whose portrait by Bellini was present in the family home in 1525 (Williamson, 1903). But other proposed identifications are those with Bartolomeo Colleoni of Bergamo, Vittore Pavoni (suggested by Heinemann, 1962, who believes the portrait to be by Gentile Bellini), and Bartolomeo d'Alviano, who according to Vasari was portrayed by Bellini (Suida, 1950; Shapley). Each of these identifications has led to different chronological placings, ranging from 1475

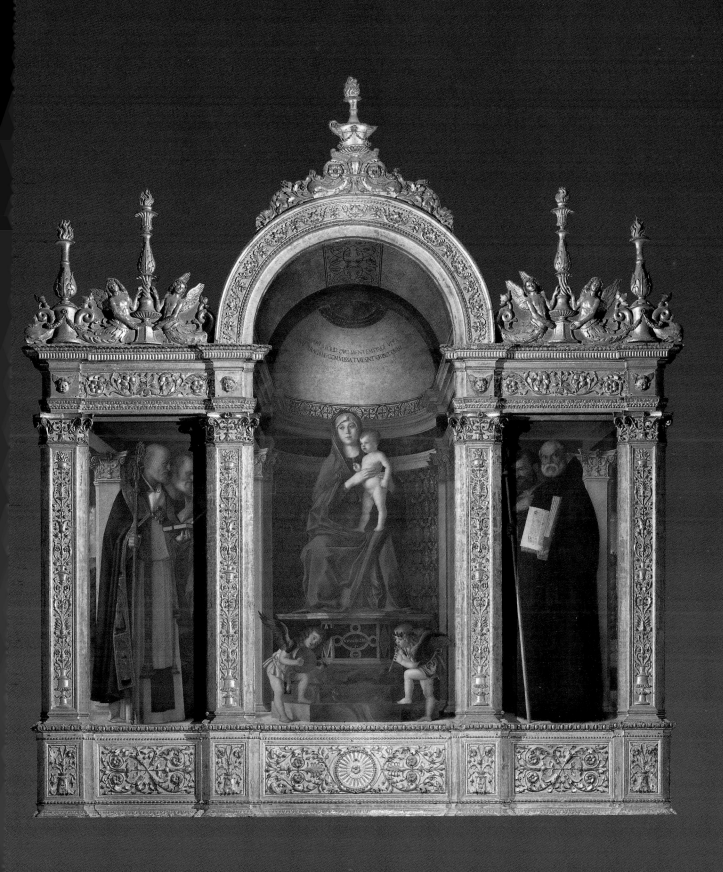

44

to after 1500. In spite of a quality that is still plastic and in relief, it seems more plausible to date the portrait to the late 1490s. The face, in fact, despite its intense bony features, is not rendered with sharp planes, but softened and furrowed by attenuated lines. Neither is the mantle any longer defined in a synthetic and hyper-realistic way by folds that are pure volume as was the case around the 1480s.

54 The *Sacred Allegory*, now at the Uffizi in Florence, may also be dated to between 1490 and 1500. The meaning of the representation is still an unresolved issue. For some decades Ludwig's interpretation of 1902 was accepted, according to which the painting translated into image a French allegorical poem of the 14th century, the *Pèlerinage de l'âme* by Guillaume de Deguilleville. This interpretation was contested by Rasmo in 1946, and other proposals followed (Verdier, Braunfels, Robertson), each of which consequently involved different datations, ranging from the 40 time of the *San Giobbe Altarpiece* to the early years of the 16th century. According to these interpretations, the painting would be seen respectively as: a "Sacred Conversation" (Rasmo); a complex allegorical representation of God's four daughters — Mercy, Justice, Peace and Charity (Verdier); the vision of "paradise" (Braunfels); or, lastly, a meditation on incarnation (Robertson). In the past the painting was for long attributed to Giorgione owing to the warm diffusion of the light, the subtle yet total naturalism, and the air drenched with golden colour. Nevertheless, the scheme used by Bellini was still the traditional one, planned according to a rational and controlled con-

*44, 45. Frari Triptych, details
Venice, Church of the Frari*

struction of the whole composition, although signs of the imminent new landscapist vision of the 16th century can be discerned. The four panels with *Allegories* at the Accademia in Venice are often likened to the *Sacred Allegory*, but they belong instead to the artist's scanty secular production. They originally formed part of a small dressing-table with a mirror and a rack on which to hang objects, belonging to the painter Vincenzo Catena who, writing his will in 1530, left it to Antonio Marsili. The spread of this kind of furniture was so great that in 1489 the Venetian Senate prohibited its manufacture, limiting it to what was strictly necessary. Often, as in this instance, their decoration comprised symbolic representations of a moralistic character.

An unusual theme for Bellini, the panels represent respectively: Lust tempting the virtuous man or Per- 56 severance (Bacchus who from a chariot offers a plate of fruit to a warrior); fickle Fortune (the woman on an 57 unstable boat holding a sphere); Prudence (the naked 58

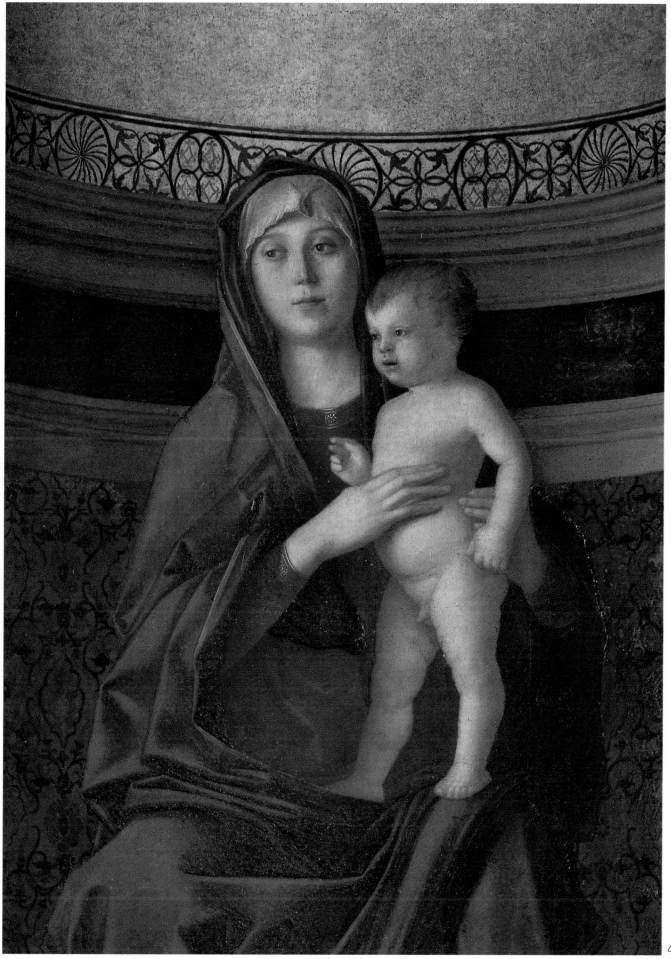

woman pointing at a mirror); Falsehood (the man emerging from the shell). There are diverging opinions about the interpretation of the last two representations, such that they have been seen as: the Woman as *Vanitas* (on the basis of similar representations by Jacopo de' Barbari and Baldung Grien), and the Man in the shell as an allegory of *Virtus Sapientia*, since the shell might have a positive connotation as a generative principle.

The proposed datations to around 1490 ought really to be brought forward, to around 1500, owing to the saturation of light and the refined unitary degree of iconographical culture which the panels attain.

The same intense golden luminosity, which can be seen in the broad horizons and an impalpable airy quality, returns in the *Madonna and Child with St John the Baptist and a Saint* of the Accademia in Venice. The work was certainly executed before 1504, since Previtali repeats the figure of the Baptist in one of his dated paintings. It is one of the artist's loftiest and most beautiful "Sacred Conversations", on the one hand embodying the still 15th-century idea of a separation between the figures and the landscape behind (the communion of the two would be achieved with the *Madonna of the Meadow* some years later), though at the same time characterized by a landscape that is laid out in the realization of a unitary naturalistic vision with limpid atmospheric values.

The *Portrait of Doge Leonardo Loredan*, the largest of Bellini's portraits, was probably painted around 1501, the year in which this aristocrat rose to the dogate. The age of the person portrayed, who held office from the age of sixty-five to eighty-five, does not indeed allow it to be dated any later. The teaching of Antonello da Messina had clearly been absorbed in the subtle realism of the facial wrinkles and the garments and, even before this, in the sitter's three-quarter turn, rather than the profile pose which was prescribed by dogal iconographical tradition and also adopted by Gentile.

The artist's progress from the early portraits is apparent, and particularly from the still pre-Antonellian *Portrait of Jörg Fugger*, fixed and linked as it is to the analytical realism of late-Gothic art. In this figure, that fixity now assumes the quality of an emblem of his own highest dignity of office: a "denaturalization" almost that crystallizes, but does not dim, the psychological make-up of this highly cultivated man, even in spite of the fact that he is rendered with solemn detachment. Any psychological eccess or a too penetrating individualization were prohibited in the name of official and hierarchical decorum. For this reason the portrait finishes by being placed in a line that is consistent more with the Venetian portraiture tradition than with the revolutionary and hyper-real portraits of Antonello da Messina.

46. *Madonna and Child, St Mark, St Augustine and the Kneeling Agostino Barbarigo (Barbarigo Altarpiece)*
200 x 320 cm
Murano, Church of San Pietro Martire

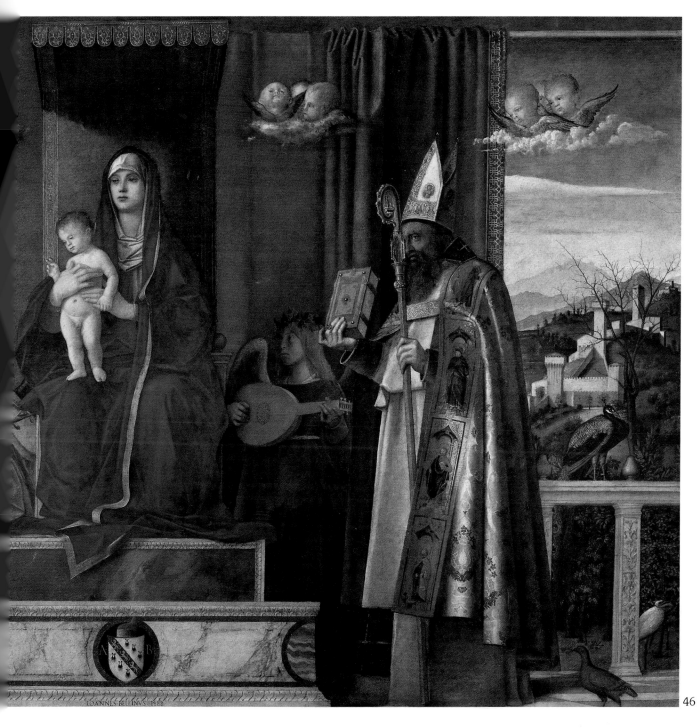

At this point we should mention the *St Jerome Reading in the Countryside* (Washington, National Gallery, Kress Collection). The painting contains an abrased and somewhat unclear inscription on the first stone at bottom left: S. MCCCCCV. It is now accepted as an autograph and resolved as: IOANNES BELLINUS MCCCCCV. But this datation creates not inconsiderable problems, since it is clear that the style is the one Bellini used not later than 1490. Various thories have been advanced, from the proposal to separate the figure from the landscape, attributing them thus to different hands (Bellini and Basaiti; Bellini and workshop), to that of a different interpretation of the date or to the late completion of a painting most of which

was executed a long time before. All things considered, the attribution to Bellini now seeming beyond doubt (although it was initially a difficult critical conquest — the example of Berenson, who changed his mind three times, in 1894, 1916 and 1957, is indicative), the latter view seems the most likely.

An intervention by the workshop, if it existed, did not go further than some parts of the landscape, like the part with the ruins above left, which does appear stiff and rather heavy. The landscape is laden with the usual symbols and religious metaphors which Bellini was very careful about (the fig-tree, the withered tree, the ivy, the layered, agglomerated, crumbling rocks, etc.). However, in the very clear landscape view all

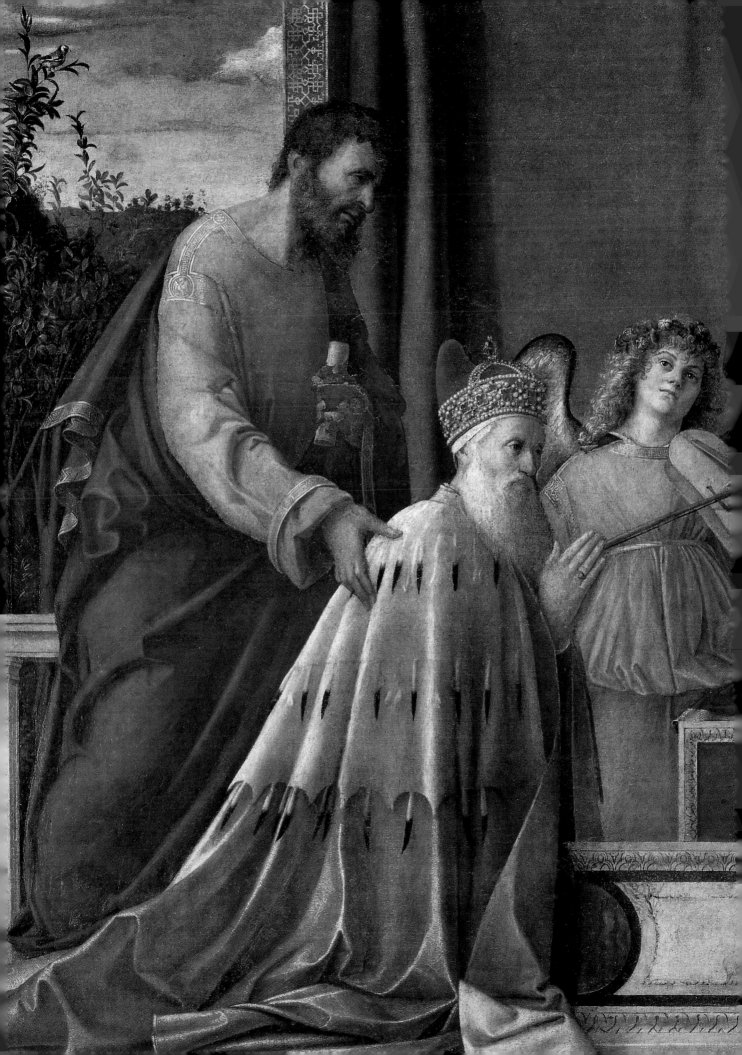

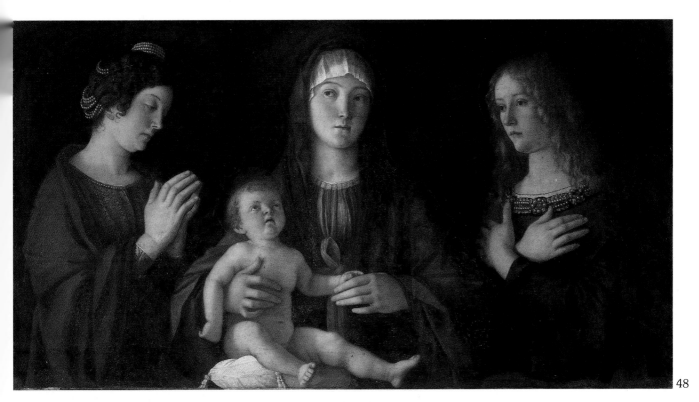

48

47. Barbarigo
Altarpiece
Detail
Murano, Church of
San Pietro Martire

48, 49. Sacred
Conversation
58 x 107 cm
Venice, Accademia

49

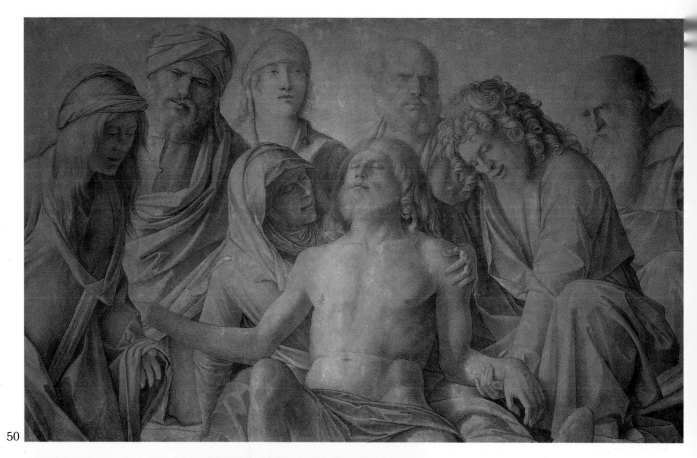

50

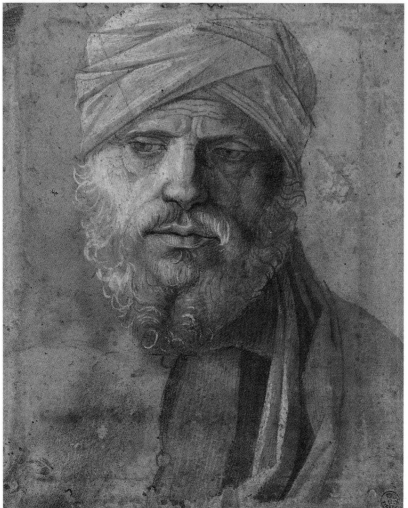

51

50. *Lamentation over the Dead Christ*
76 x 121 cm
Florence, Uffizi

51. *Man with a Turban*
Florence, Uffizi (Gabinetto dei Disegni
e delle Stampe)

52. *Portrait of a Condottiere*
51 x 37 cm
Washington, National Gallery of Art

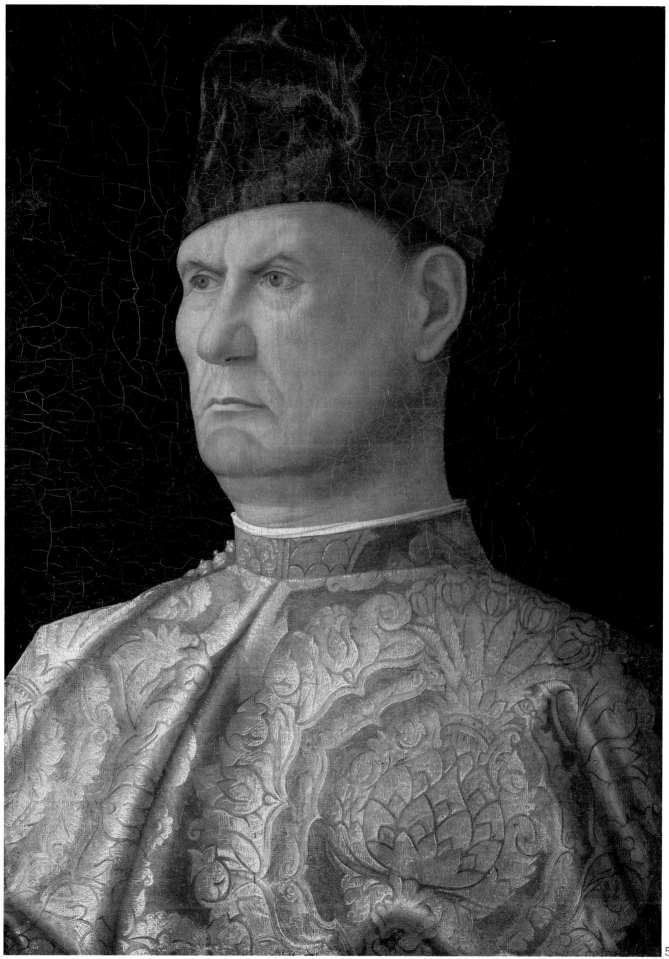

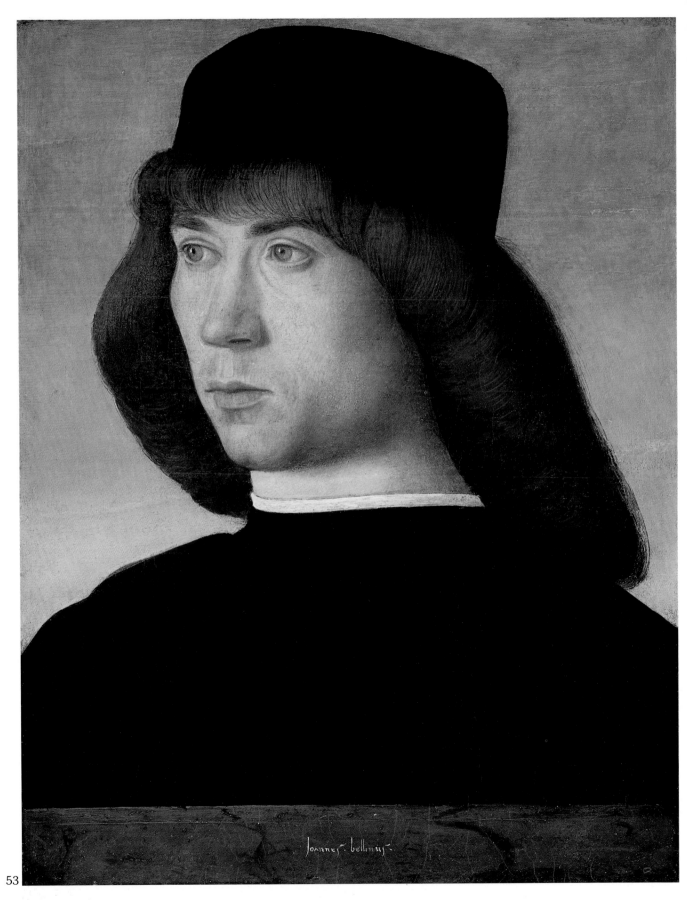

53

53. Portrait of a Young Man
31 x 25 cm
Washington, National Gallery of Art

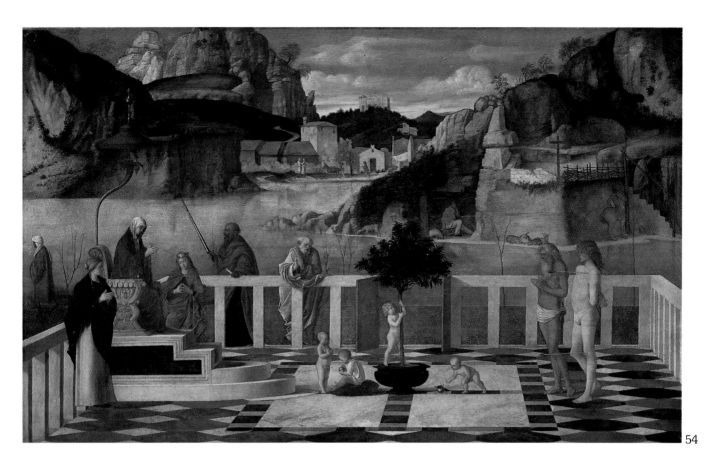

<div style="text-align: right;">54</div>

54. Sacred Allegory
73 x 119 cm
Florence, Uffizi

these elements, affectionately and lyrically portrayed one by one, have not yet found the sublime harmony that was typical of the backgrounds which Bellini painted after 1500, and appear here more like a kind of splendid naturalistic compilation. Nor, on the other hand, are there substantial differences between this and the other autograph version of the theme, formerly in the Contini Bonacossi Collection in Florence and since 1974 at the Uffizi.

Reattributed to Bellini for the first time by Gronau in 1928, after having been assigned to Marco Basaiti for decades, and datable to around 1505, the *Madonna of the Meadow* is one of Bellini's undisputed masterpieces. Unfortunately a far from excellent state of preservation (partly due to its transfer from wood to canvas in 1949) has compromised the quality of its colour composition, especially in the group of the Madonna and Child. The image is a kind of synthesis of Bellinian dictates, a height of unattainable unity of poetry and metaphorical and religious meanings, which Bellini's complex culture on the one hand and his emotional depth on the other succeed in reaching.

Few works, in fact, have such a highly developed double nature, demanding therefore a comprehension and an interpretation that take account of different levels. Unequivocal is the poignant lyricism of the landscape, and its rarefied and intensely limpid presence. "A calm that ranges among the eternal sentiments of man: dear beauty, revered religion, eternal spirit, living sense; and a choral reconciliation that blends and softens the sentiments" — thus Longhi (1946) described Bellini's landscapes, with words that were admirably suited to the *Madonna of the Meadow*, while Pignatti sees in it "a truth so real that it now betrays the prevailing interest of the artist". But the sky pervaded by an infinitely serene light and, against its deep blue transparency, the golden weightless trees, the neat graceful buildings, the air devoid of sounds or disturbances, are also the ideal representation of the *quies*, "spiritual reconciliation, idyllic or ascetic retreat into solitude", which Battisti cites as the guiding principles of the Marian concept. Nor must we forget that if the Madonna sits down in a barren rocky land it is because she is a Madonna of Humility; if the lush and minutely depicted greenness of a meadow extends around her it is an allusion to the *hortus conclusus* of medieval hymns, while in the background other attributes referring to her are added: the *Turris* (the fortress on the hill), the Doorway, the *Puteus* (the well), the clouds (symbol of the humanity of Christ and also of the divine mysteries), the struggle between the pelican and the snake.

<div style="text-align: center;">53</div>

55

A concentration of symbols and intellectualistic configurations, as can be seen, which does not in the least way dim the emotive and aesthetic quality of the work, but on the contrary seems to exalt it in a total harmony. "Here", writes Battisti, "it is as if the symbolism was so evident as to become a kind of commonplace, presupposing that the spectator knew it and sought after it — like a modern iconologist — for prior information. No emotion, no surprise, except that persuasive one of affection, is thus produced by this painting that was conceived by way of a prolonged contemplation" (1980).

A similar interpretation and sentiment concern the following Madonnas: the *Madonna and Child Blessing* of the Institute of Art in Detroit, dated 1509, and the 67 one dated 1510 at the Brera in Milan. Although in both of them the curtain returns to separate the holy group from the surrounding landscape, a new vision that takes account of Giorgione's innovations, and absorbs them, blends the natural elements with the human presence. The analyses carried out on the occa-

55. Sacred Allegory, detail
Florence, Uffizi

56. Perseverance
32 x 22 cm
Venice, Accademia

57. Fortune
33 x 22 cm
Venice, Accademia

58. Prudence
34 x 21 cm
Venice, Accademia

59. Falsehood
34 x 22 cm
Venice, Accademia

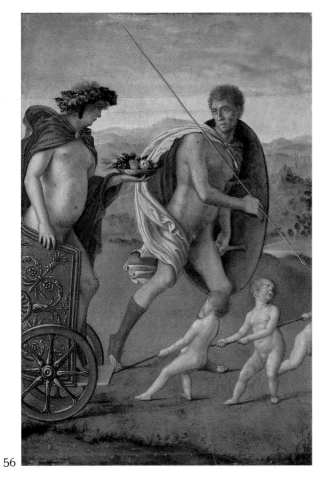

56

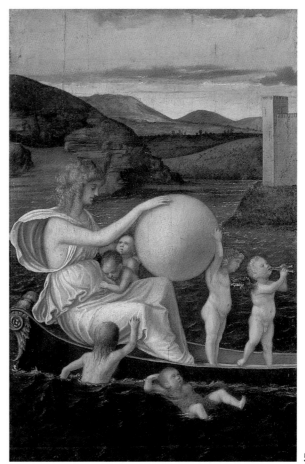

57

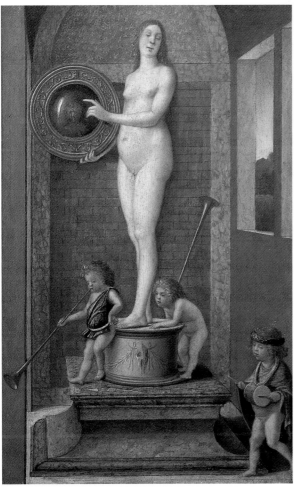

58

59

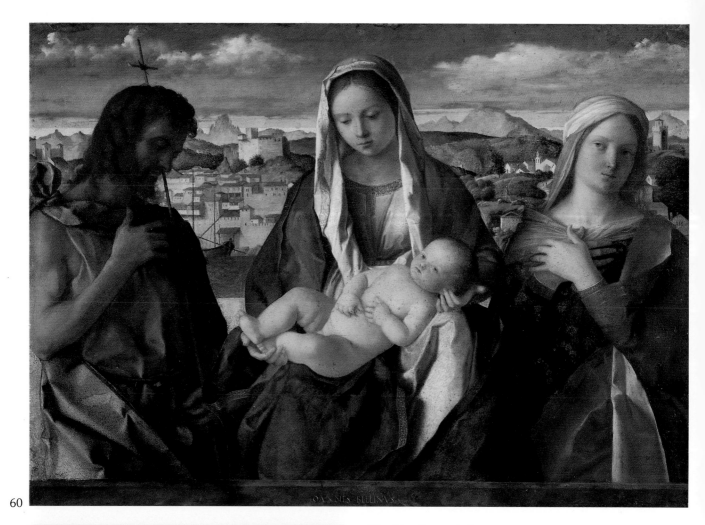

60

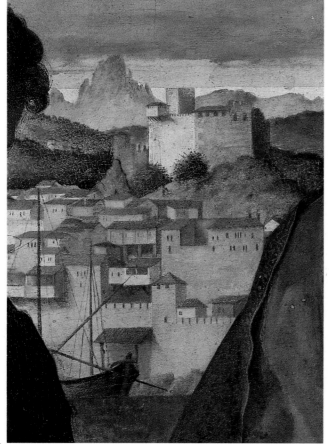

61

60, 61. Sacred Conversation
75 x 84 cm
Venice, Accademia

62. Portrait of Doge Leonardo Loredan
61,5 x 45 cm
London, National Gallery

sion of the last restoration (1986) revealed, in the Brera painting, the absence of a preparatory drawing in the landscape. This confirms that, while for the figures Bellini still felt the need to lay out the image beforehand, by this time he had a full and total confidence in the manipulation and figurative arrangement of the landscape. Over the preparatory ground he proceeded with light strokes, on which he often intervened with his finger-tips.

Even fifty years after the beginning of his career Bellini had not abandoned the habit inherited from his father Jacopo of the sketch in a notebook and the sin-

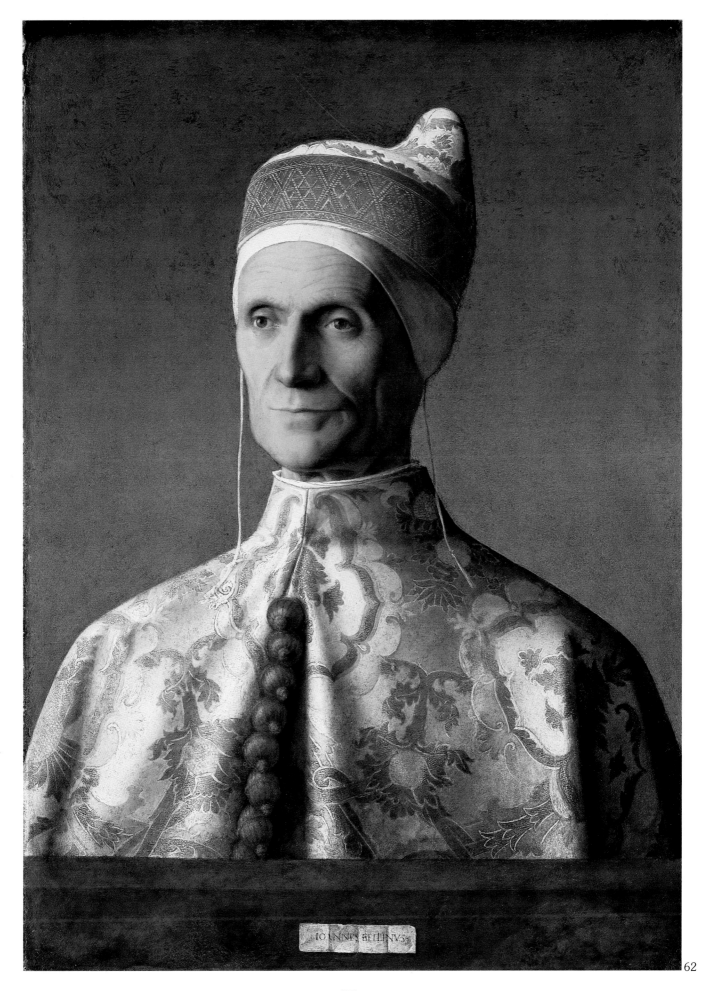

IOANNES BELLINVS

62

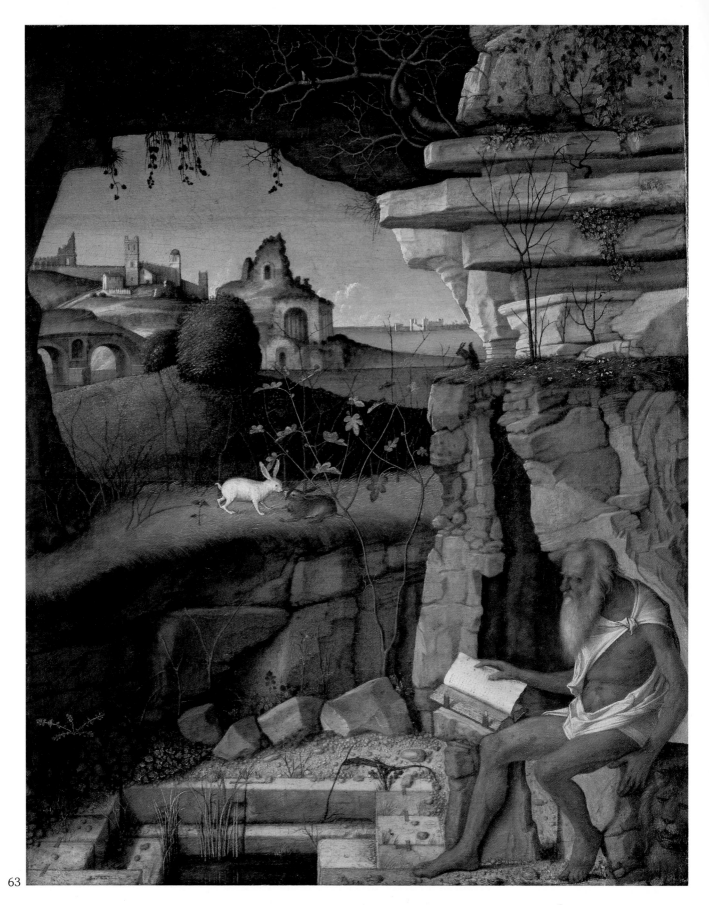

63

63. St Jerome Reading in the Countryside
49 x 39 cm
Washington, National Gallery of Art

64, 65. St Jerome Reading in the Countryside
145 x 114 cm
Florence, Uffizi

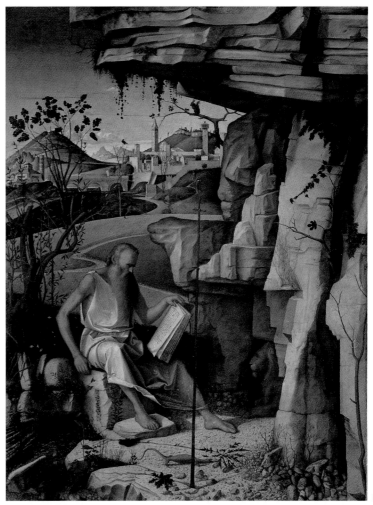

64

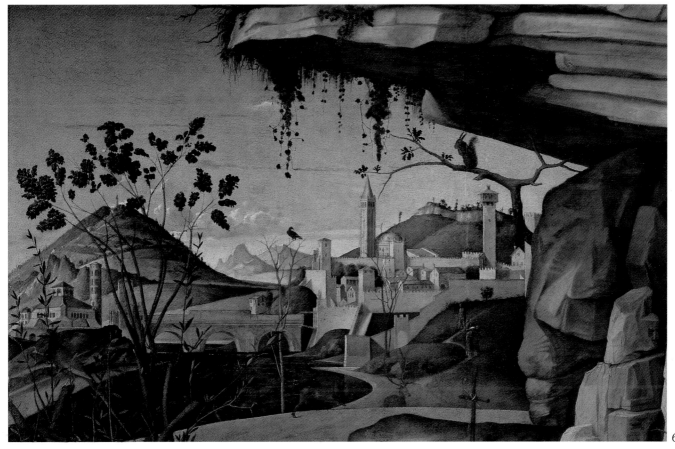

65

66

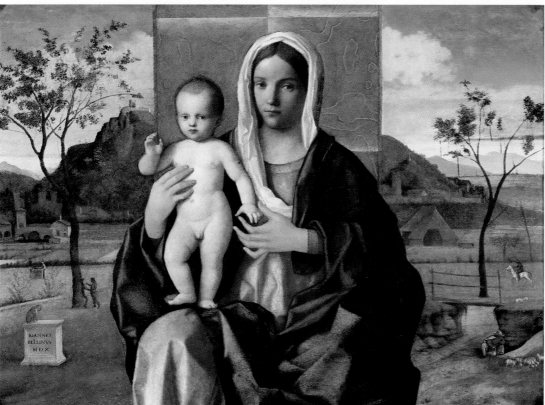

67

*66. Madonna
of the Meadow
67 x 86 cm
London,
National Gallery*

*67, 68.
Madonna
and Child
85 x 118 cm
Milan, Brera
Gallery*

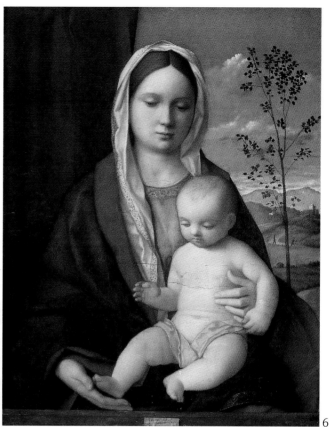
69

gle study from life. Here, then, is a tiny cheetah on the classical memorial stone, farming activities, and animals. The result is a transparent landscape with a 68 light, ordered structure. Although, in this respect, it is certainly still linked conceptually to the Quattrocento, the light is now so much the essence of it that it transforms and directs it toward tonalism. The organization of the image is quite unitary, also because it is bathed in a soft, gentle, auroral light that alludes to the dawn of a new era.

The same softness of colour and the same gentleness in the group of the "Madonna and Child" return in the signed canvas of the Galleria Borghese in Rome, 69 chronologically very close to the Brera painting. Yet another variation on a theme that was among the dearest to the painter, this is probably its last fully autograph version. We do not agree with Heinemann, in fact, who with Dussler considers it the work of the workshop. On the contrary, the expanded forms, the curvilinear widening of the volumes and the chromatic intensity are all elements that unequivocally point to the last phase of Bellini's career, as is the more relaxed connection between mother and child, where the Madonna does not hold the child closely to her in an attitude of yearning affection, but proffers it quietly to the adoration of the spectator.

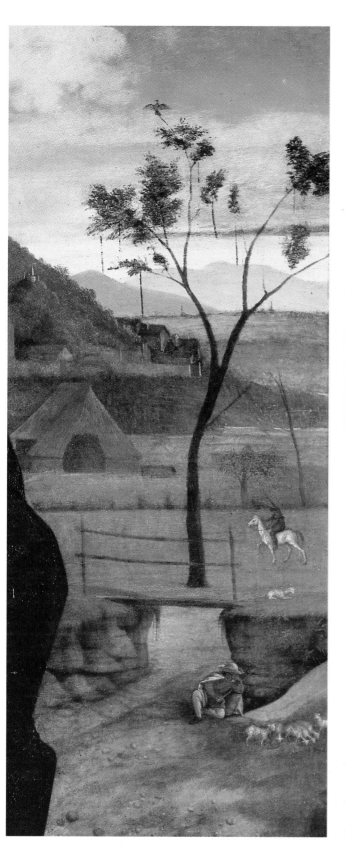

69. Madonna and Child
50 x 41 cm
Rome, Galleria Borghese

The late works

70 Bellini's last phase is heralded with the *Madonna and Child Enthroned with Saints Peter, Catherine, Lucia and Jerome* of the church of San Zaccaria in Venice, dated 1505. According to Ridolfi (1648) the altarpiece, commissiond in memory of Pietro Cappello, was already in its own time "considered one of the most beautiful and refined works of the master". Bellini was now an old man of about seventy-five. Yet his astounding ability to change, arising from a conscious understanding of the evolution of art, does not appear to have dimmed for a moment. Confronted by the first achievements of Giorgione, he assimilated and adapted them to his own artistic expressivity with total coherence. The compositional and architectural structure of the canvas is not fundamentally very different

40 from the *San Giobbe Altarpiece*: a niche-like apse surrounding the group of the enthroned Madonna and the saints who are positioned at her sides. Here too, from a spatial point of view, the painting becomes a continuation of the altar on which it is placed. But at the same time the landscape appearing from the sides, according to an idea taken from Alvise Vivarini who had experimented it in the Battuti Altarpiece at Belluno (now destroyed), pour forth into the air a light that softens the forms. The tonal colour gains the upper hand, creating a new harmony of broad planes, softened forms, and a warm sense of the air. In his turn Giorgione must have contemplated this elaboration the old Bellini was making of his inventions, and kept it in mind in the frescoes of the Fondaco dei Tedeschi of some years later.

On 23 February 1506 (*more veneto*), according to the entry recorded by Marin Sanudo in his *Diaries*, Gentile Bellini died. Sanudo added a celebrated annotation to this death, according to which "the brother Zuan Belin remained, who is the most excellent painter in Italy". The equally well-known letter written by Albrecht Dürer, then staying in Venice, to W. Pirkheimer, was of only a few days earlier. In it the German painter praised his old Italian colleague for the generosity and loyalty that the latter had shown by publicly declaring his esteem for him. ". . . Giovanni Bellini. . . has praised me in front of many nobles, and wanted to have something of mine. In fact he himself came and asked me to paint something, promising that he would pay well for it. Everyone had told me that he was a great man, and he is indeed, and I truly feel myself his friend. He is very old, but he is undoubtedly still the supreme painter".

From the few references of his contemporaries, Giovanni Bellini emerges as a person who in his old age had reached an extremely high level and in no way suffered a regression. His moral stature was undisputed, as was his prestige among colleagues, who regarded him as a grand old man, lucid and well-balanced. In a certain sense he was, in the last phase of his maturity, exactly as we would expect a man to be who in the course of his life had been able to express such a total harmony, and such a supreme and serene religiosity.

On the death of Gentile, Giovanni Bellini inherited from his brother the celebrated sketchbooks of their father Jacopo, though on one condition: that he finish the large canvas with the *Sermon of St Mark in Alexandria*, commissioned by the Scuola Grande di San Marco, which Gentile had started in 1504. On 18 February 1506, in fact, when Gentile dictated his last will, the canvas was already "in large part done", though not finished. It was the Scuola di San Marco itself that confirmed Bellini's assignment to complete the painting on 7 March of the same year, a few days after the death of his brother.

The plan of the large "historia", conceived as an ordered representation on a wide stage closed on three sides by large architectural walls, was clearly Gentile's. The style of the architecture, suggested to the painter during his journey in the East (where, as we have already mentioned, he had been sent by the Republic in 1479 in the retinue of a diplomatic mission) is reminiscent of Mameluke prototypes, which led Meyer Zur Capellen (1985) to speculate that Gentile may have proceeded from Constantinople to Jerusalem on a pilgrimage, and from there have recorded new architectural ideas that were different from Ottoman styles, the latter being more familiar to Venetians.

The official narrative, however, hinges on the crowd gathered around the preaching saint in the square, where, according to Venetian canons of public portraiture, the characters appear as a socially and hierarchically defined group.

Critics have advanced a number of theories concerning the extent to which either brother was responsible for the painting of this large human group. Apart from Vasari, who in the first edition of the *Lives* (1550) mentioned Gentile as the only author of the painting, only to drop this idea in the second edition (1568), the old historiographers attributed the *Sermon* to both

70. San Zaccaria Altarpiece
500 x 235 cm
Venice, Church of San Zaccaria

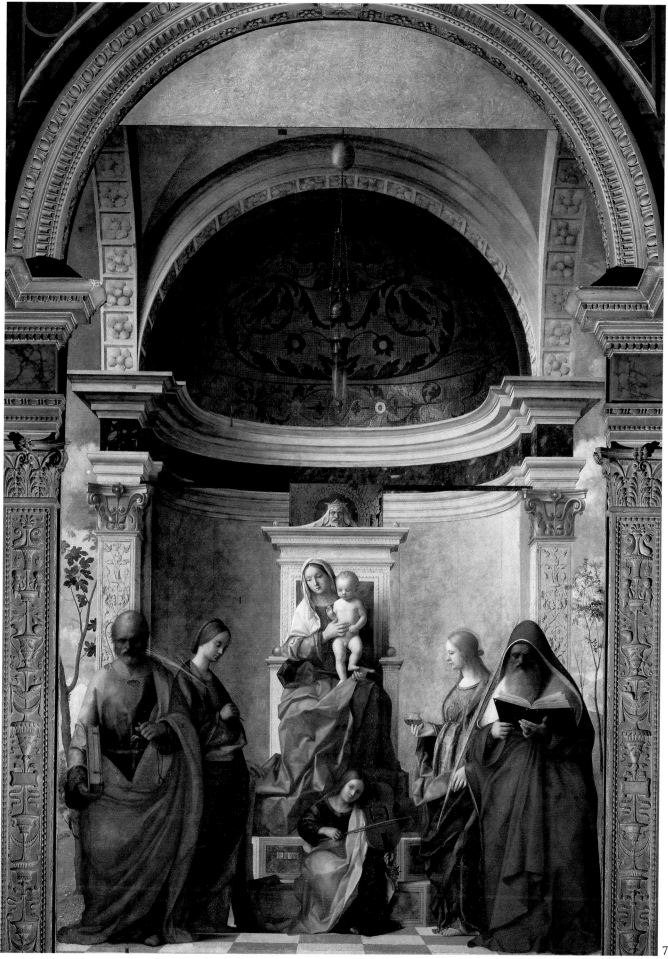

71

brothers without entering into detail about the individual contributions.

Of the modern critics, Pallucchini (1959) sees Giovanni as the hand behind the more precisely psychologically analyzed portraits, placed in the central 74 group, many of whom are shown with a three-quarter turn, and of some characters on the far left. Arslan (1962) asserts that St Mark himself, in addition to the senator listening on the right, may be the work of

71. San Zaccaria Altarpiece, detail
Venice, Church of San Zaccaria

72. San Zaccaria Altarpiece
Detail of St Lucia and St Jerome
Venice, Church of San Zaccaria

Giovanni. Bottari (1963), more extensively, attributes to Giovanni the figures in the background, those around and on the left of the saint, in addition to the general "light opening". But Gamba (1937) had already observed that other finished canvases by Gentile, like the *Procession of Piazza San Marco*, were characterized by "a bright and fair painting. . . though without liveliness and without air" and therefore gave to Giovanni the merit of having made "air and light circulate among the groups and around the buildings. . . lightening shadows and harmonizing harsh contrasts of colour. . .".

Here too the research carried out before and during the last restoration was useful in giving new and more precise answers to the problem, revealing the numerous modifications of arrangement and character that some faces have undergone, and the additions and corrections applied to a part of the drawing of the buildings.

But beyond the precise detailed statements, which are in fact secondary, the intervention of Giovanni should be evaluated on the overall conception of the composition. Moving and animating the characters, indeed, restoring to them a unique and peculiar individuality, lightening, even if slightly, the severity of Gentile's "order", Giovanni went beyond the solemn historical consecration typical of his brother's great narrations and imprinted in the "story" a human dimension together with a masterly development towards modernity.

Around the middle of the first decade of the 16th
75 century we must also place the *Pietà* of the Accademia in Venice, once the property of the Martinengo family and later transferred to the Donà delle Rose family. In the background, beyond the emblematic fig-tree, rises
76 a walled city in which the main buildings of Vicenza can be identified: the Duomo, the Torre, the pre-Palladian basilica, as well as the bell-tower of Sant'Apollinare Nuovo in Ravenna and the Natisone at Cividale. But we reach the background only later, after having been attracted by the intense dramatic force of the group in the foreground. The Madonna holds the dead Christ in her lap, almost overwhelmed and bent down by the weight of her son's body that seems to slide away from her. Her face, faded by old age, appears worn out and exhausted through her suffering. Christ's abandonment, suggested by his hair hanging against the splendid, lenticular symbolic patch of grass (the Marian *hortus conclusus*) which blooms behind the figures, is stiffened to the point of attaining a Dürer-like quality in the contorted hands. The sharp drape on which the body is lain is also reminiscent of Dürer.

Gronau (1928) rightly compared the work with Northern wooden sculpture and the tradition of the *Vesperbilder* (Pietà). To this we may add the research,

73. *Sermon of St Mark in Alexandria*
347 x 770 cm
Milan, Brera Gallery

0 as in the previous *Sacred Conversation*, of a landscape view widened at the horizon and as unitary as possible despite being still separated from the figures. This was in fact Bellini's main problem during those '7 years. The *Continence of Scipio* (Washington National Gallery, Kress Collection) was the last operative meeting-point of Andrea Mantegna and Giovanni Bellini, who were by this time not only old men but exponents of entirely different figurative styles.

According to Longhi (1951), in fact, Bellini's frieze represents the continuation of Mantegna's, who painted *Scipio Receiving the Image of Cybele*. The canvas by Mantegna, which is now at the National Gallery in London, had been commissioned by the Mantuan Francesco Cornaro for the decoration of his house at San Polo in Venice. At the time of payment, however, there was some disagreement between the client and the artist, which we know about from a letter written by Bembo to Isabella Gonzaga in 1505. The monochrome painting was consequently not delivered to Cornaro, and his family received it only later. At the time of the painter's death in September 1506, the question was still a matter of controversy (to the extent that the painting was still in Mantegna's house) and the cycle thus remained completely interrupted.

In his own frieze, Mantegna had painted an episode from the Second Punic War: the introduction of the cult of Cybele in Rome, an event, according to the oracle of Delos, to which the victory of Rome was subordinated; kneeling in the presence of the goddess's likeness, the matron Claudia Quinta proves her chastity. The choice of the subject was fitting, since the client's family boasted descent from the Roman family of Cornelius, to which Scipio belonged; although for that matter it was no less fitting for the artist, whose love for classical antiquity and archeological studies was very well-known.

For Bellini, on the other hand, probably called to replace Mantegna after his death in 1506, both the subject and the technique (a false relief painted in monochrome) represented a "one off" in his artistic career. The episode depicted, narrated by Livy and Valerius Maximus, tells of how after the taking of Carthage in 209 BC Scipio had treated with respect a beautiful virgin, one of the hostages who had been consigned to him, and had sent her back to her intended husband and parents with the sole recommendation that her suitor strived for peace between Rome and Carthage. The parents present themselves before Scipio, enthroned after his victory, who refuses to ac-

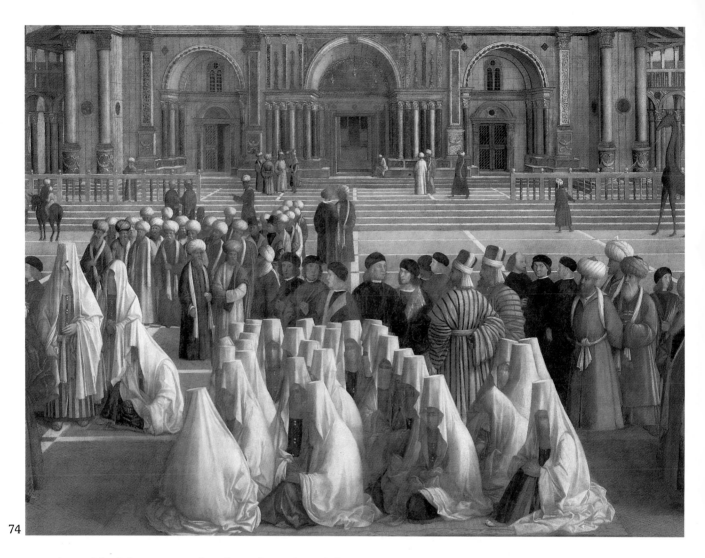

74

cept the gold of the ransom they have brought, while the maiden's gallant, with sword and helmet, listens to the generous sentence. In the Mantegnesque painting, female virtue is represented by the episode of Claudia Quinta; in another two minor monochromes (both at the National Gallery in London), which Longhi joined to the series (though this was disputed by Titze Conrad, 1955), another two "virtuous" women are represented — the Vestal Virgin Tuccia and Queen Sofonisba — signifying that the cycle was intended to celebrate not only the nobility of the Cornelius family, through the triumphs of Scipio, but also their moral virtues.

In the works of Andrea Mantegna and Giovanni Bellini we may now contrast thematic continuity with profound stylistic and ideological differences: the grandiose, articulated and distinctly stony Mantegna, more than ever absorbed in his lucid, haughty archeological celebration; while Bellini, who has now fully assimilated the teaching of Giorgione, is musically *chiaroscural*, despite the presence of some drapery reminiscent of Dürer.

Although part of the composition is probably to be ascribed to the workshop (Robertson sees it as an execution by assistants on the master's drawing), in the

74. *Sermon of St Mark in Alexandria, detail*
Milan, Brera Gallery

75, 76. *Pietà*
65 x 90 cm
Venice, Accademia

Triumph the "soft pictorial structure" (Pallucchini, 1959), which dissolves the Mantegnesque classicism into an animated and lively sequence, is Bellini's.

This warm, vital interpretation of classicism, to which the new dimension of Giorgionesque neo-Platonism is certainly not unrelated, would be fully realized in the *Feast of the Gods*.

In 1513 Bellini signed and dated the altarpiece with *Saints Christopher, Jerome and Ludwig of Toulouse* of the church of San Giovanni Crisostomo in Venice.

The painting had ben commissioned in 1494 by the merchant Giorgio Diletti, who had left instructions in his will for the construction of an altar and the execution of an altarpiece to go with it representing Saints Jerome, Ludwig and Crisostomo. The almost twenty years that elapsed between the ordering and execution of the altarpiece, and the partial modification of

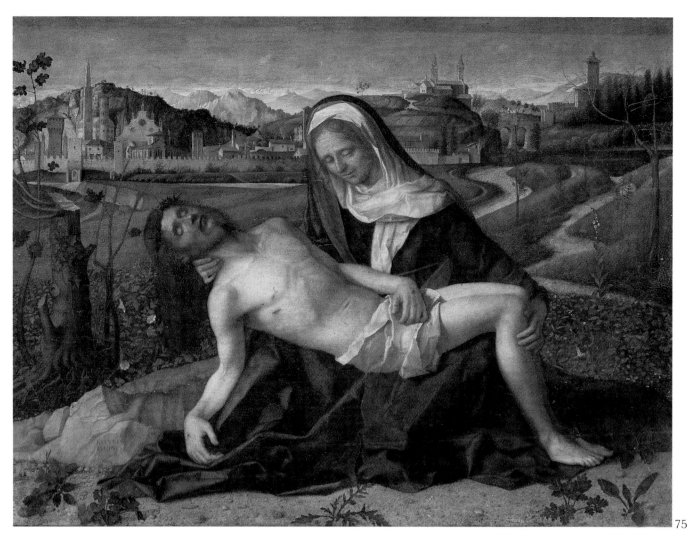

75

76

the identity of the saints requested by Diletti, have raised a number of queries which scholars have only partly resolved. The first uncertainty concerns the bishop saint on the right holding a book bearing the inscription "De civitate Dei", which has led some scholars to identify him with St Augustine. However, the inscription on the book is almost certainly a later addition: its extraneousness is revealed by the fact that it is written on the back of the volume and by the uncertainty of the inscription itself, unimaginable in Bellini who was always highly accurate and extremely precise. Besides, the Anjou lilies on the bishop's cloak confirm that it must be the French noble Ludwig, who renounced the throne to become a Franciscan. According to the complex iconological interpretation of the altarpiece furnished by Lattanzi (1981), St Ludwig in his lavish bishop's robes represents a pastoral and liturgical significance. In this he provides a contrast with Christopher, an emblem of the active faith and preaching, and both are placed under an arch, a symbolic image of the church, on which the second verse of Psalm 14 is written in Greek: "The Lord looked down from heaven upon the children of men, to see if there were any that did understand, and seek God". The choice of the Greek language is explained, besides the fact that the church of San Giovanni Crisostomo was the centre of the Greco-Venetian community, also by remembering Bellini's contacts with the erudite circle that revolved around Aldo Manuzio. Manuzio, indeed, is credited with an important edition in Greek of the *Psalter*, which was printed between 1496 and 1498.

Beyond the parapet St Jerome, a hermit and doctor of the Church, represents the highest point of spiritual life, that of mystical exaltation and revealed science. Beside him the fig-tree symbolizes that he has been chosen by the Lord to understand its supreme law.

77. *Continence of Scipio*
75 x 36 cm
Washington, National Gallery of Art

According to this interpretation we are therefore confronted by a clear, conscious stand-point in the contemporary religious debate that existed in Venice during those years: a position by which action and contemplation are a unitary moment in the ecclesiastical path.

Undoubtedly such a complex and culturally significant proposition must have been established by the client in the first place; nonetheless, Bellini's humanistic and theological lucidity too is certainly confirmed once again.

The temptation to underestimate the cultural significance of both Bellini's religious and profane works, indeed, has been so great in the face of his great stature as an artist, that we tend to forget, or even consider with some irritation, the possibility that they also contain a historical or political value of not inconsiderable weight. We must bear in mind that this was certainly not lacking in the work of Bellini, who in painting perfectly reflected the climate that was abroad in the Venetian intellectual coteries frequented by humanists, scholars and literary men such as Ermolao Barbaro, Domenico Grimani and Girolamo Doria.

Bellini's last phase, which we are able to identify through several key works, reveals a number of new ideas and confirms his extraordinary receptivity to and awareness of the latest developments in art.

The *Drunkenness of Noah* of the Musée des Beaux 79 Arts in Besançon belongs to this last period. It was Longhi, 1927, who first intuited that this canvas (attributed to Cariani by Berenson) belonged to the master's late maturity. Apart from Gilbert (1956) and

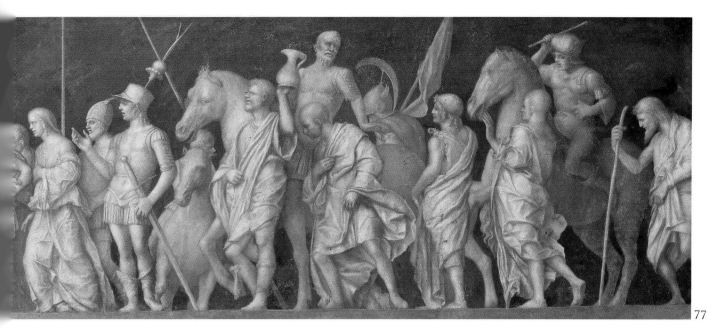

Heinemann (1962), who assigned it respectively to the circle of Lotto and of Titian, the autography of the *Drunkenness of Noah* was gradually accepted by everyone (including Berenson in 1957), to the extent that it has become an important point of reference for the reconstruction of these years.

The wide planes, the reddish and purplish hues and the dense pastiness of the oils are elements which characterize Bellini's "Giorgionesque" works. The composition, which is developed horizontally, is full and united more than by the supine figure of the old man, by the apparently disordered series of gestures that join the figures together. Here too, however, we witness Bellini's acceptance of the new 16th-century developments in art, without a renunciation of his old 15th-century grounding which was faithful to the preparatory drawing. The drawn framework, indeed, is still discernible in the careful perspective study which elbows, hands and knees reveal in their complex juxtaposition.

81 The *Young Bacchus* (Washington National Gallery, Kress Collection) must be regarded as contemporary, a small panel work transferred onto canvas, formerly assigned to Basaiti, though now accepted as one of Bellini's last works; also accepted is its identification (proposed by Gronau for the first time in 1930) with the *Young Bacchus Holding a Vase* attributed to Giorgione, which Ridolfi saw in the property of Bartolo Dolfini in Venice in the middle of the 17th century. Shapley (1979) suggests a metaphorical rapport between the representation of the child god and the alternation of the seasons, in the same way in which it is drawn in Macrobio's *Saturnalia*, which was printed with commentaries in the humanistic age. The idea of the winter solstice, the shortest day of the year, would correspond with the smallness of Bacchus. Certainly the small Bacchus must be seen as very close to the *Feast of the Gods*. Indeed, the resemblance between 82 the Bacchus of the *Feast* and the *Young Bacchus* has been pointed out several times. In the small canvas, however, we witness yet again the incredible openness that the almost ninety year-old artist succeeded in advancing in his affirmation of a new profane sensibility, the same that ran through the *Naked Woman in* 80 *front of the Mirror* of the Kunsthistorisches Museum in Vienna and the *Drunkenness of Noah* of the Musée 79 des Beaux Arts in Besançon. We therefore do not share Shapley's theory of an earlier dating of the work to 1505-10. The same landscape background against which the young Bacchus is seated was by now an image that was so essentialized and reduced to pure ideal substance that it seems referable only to the other foreshortening, similarly idealized and eternal, of the Viennese *Naked Woman*. Also in addressng himself to and portraying nature Bellini had covered a considerable distance. One might say, indeed, that he no longer needed to look at it or represent it with elements that were in some way real or recognizable; nor did he need to animate it in any way. He gave only its pure structure, the inner and "philosophical" vision.

But the masterpiece of these years is the *Feast of the* 82 *Gods*, signed and dated 1514, now at the National Gallery of Art in Washington, which for a number of reasons is a somewhat problematical painting.

On 14 November 1514 the ducal chancellor of the House of Este paid Bellini the sum of eighty-five golden ducats for a "pictura", the *Feast* in other words, which by that time was certainly finished. Yet again, however, critics have taken up various positions regarding the date it was begun. In 1948 Wind was the first to advance the theory that the painting might have been started some years earlier for Isabella d'Este; the correspondence between Isabella and Pietro Bembo reveals how in 1505 Bembo had been charged by her

to press Bellini to execute a painting on a profane subject for her *studiolo* in Mantova.

Successive critics lined themselves up variously for and against this proposal. Pallucchini, Arslan, Pignatti and Bottari were particularly in agreement with Wind. But what fundamentally is attractive about this critic's idea is the anticipation — as regards the date signed on the painting by Bellini himself — of the plan and draft of the *Feast*. This would in fact explain some characteristics, already noted by Vasari who wrote, ". . . it is one of the most lovely works that Bellini ever did, although in the manner of the clothes it is somewhat harsh, according to the German style; but this is no surprise since it imitated a painting by the 'Flemish' Albrecht Dürer. . .". Bonicatti does not take up any position on the Isabella theory, but agrees with the chronological anticipation of the commencement, even fixing it at 1505-06. By reason of its rough similarity with the *Detroit Madonna*, Pallucchini tends more toward 1509. Certainly, especially in some drapery and in the rocky foreground, the *Feast* really is "somewhat harsh", which partly contrasts with the full-bodied forms and the warm tonalism of the colour. However, a delay of many years in the execution of the work does not seem plausible. The choice of a subject so unrelated to Bellini's customary main themes, moreover, so obviously indicates the influence of the new Giorgionesque culture on the old master as to dissuade us from considering a too premature starting-point.

On the other hand, the datation is nothing other than one of the open questions about the *Feast*. It was originally in the so-called "alabaster chamber" of Alfonso I d'Este in Ferrara. This small room, used as the duke's study, was situated in Alfonso's private apartment in the "covered way", which connected the Castle of Ferrara to the Ducal Palace. It probably took its name from the marble reliefs by Antonio Lombardo that were in it. The painted "historie" ordered to decorate it, according to a scheme worked out by Alfonso himself, possibly with the assistance of humanists like Mario Egnicola (Robertson, 1968), also included three paintings by Titian when the decoration was completed (*Bacchus and Ariadne*, London, National Gallery; *Offering to Venus* and *The Andrians*, Madrid, Prado) subsequent to Bellini's *Feast*, and indeed actually wanted by Alfonso to accompany it. The artists contacted by the Duke to complete the decoration of the room had been: Fra Bartolomeo, who died before being able to paint anything; Raphael, who also died after having prepared only some drawings which were never translated into finished works, and lastly Titian, who accomplished his own paintings taking into account the ideas that had belonged to his predecessors and which are evidenced by old copies and drawings.

According to Vasari, Titian also intervened directly on Bellini's *Feast*, "whose work not having been able to finish completely, for he was an old man, was given over to Titian, as the most excel. Of all the others, who completed it". Only the X-ray test carried out in 1956 resolved the debates and varying interpretations which had arisen from this sentence of Vasari's. They revealed that the painting had three different drafts; an original one by Bellini; and another two, partial and later, which may be interpreted as "revisions" of a short time after, one belonging to Dosso and the other to Titian and which mainly regard the woody landscape that provides the scene's background. Bellini had in fact conceived and painted a landscape containing only a few scattered trees with light foliage. This was transformed by the overpaintings, first into a landscape with ruins and houses and a dense leafy wood, then, in the final version by Titian, the present one, into one that is dominated by a rocky spur set against a cloud-filled sky. The poses and clothes of some of the figures were also changed, or an attribute pertaining to its divinity was added (Neptune's trident, Apollo's lyre, etc.). According to Shapley two corrections are not attributable either to Titian or Dosso, but to yet another painter: the left arm of Cybele and the right arm of Neptune, which are rather coarsely finished.

According to the current interpretations, the scene illustrates a passage from Ovid's *Fasti*. Priapus, the god of fertility, takes advantage of the moment in which the other gods are drowsy with wine during a feast held by Cybele, in order to seduce the goddess of chastity, variously indicated as Vesta or Lotos. But he is discovered because the gods are brusquely awakened by the braying of Silenus's ass. The pheasant on the tree, a bird known for its promiscuity and like all birds chattery and therefore traitorous, was therefore an allusion to the secret revealed.

P. Fehl (1974) recently advanced an interpretative theory attributing the modifications to the hand of Bellini on the basis of chronological considerations and not according to the generally proposed and accepted reasons of stylistic harmonization with other paintings in the *studiolo*. According to Fehl, in fact, Bellini had initially illustrated not the *Fasti*, but a passage of the *Vulgarized Ovid* published by Giovanni de' Buonsignori.

In this text the feast is actually a bacchanalia, and those assembled not gods but men. From this derived

78. Saints Christopher, Jerome and Ludwig of Toulouse
300 x 185 cm
Venice, Church of San Giovanni Crisostomo

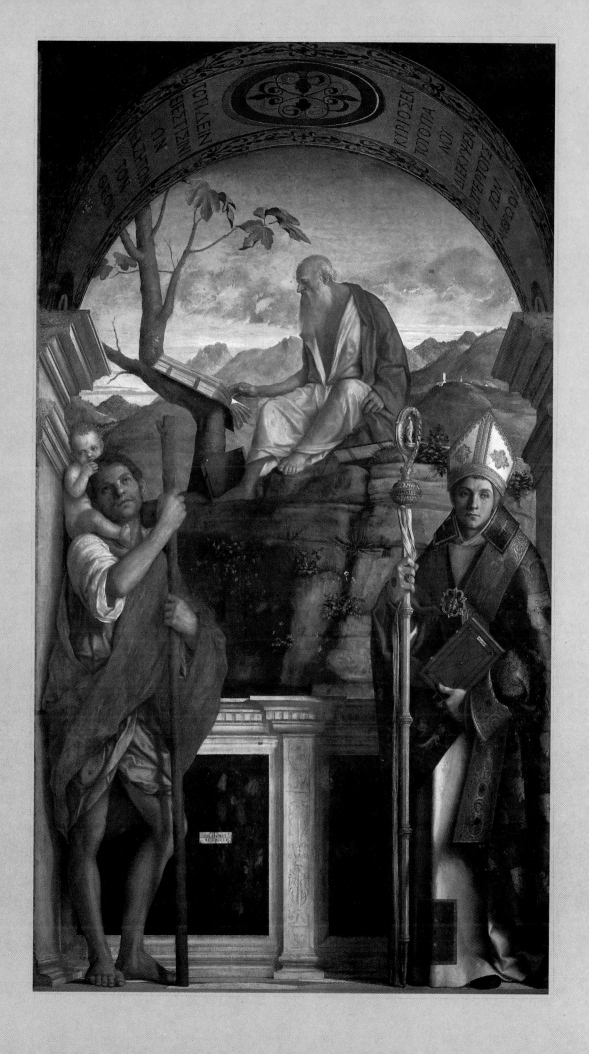

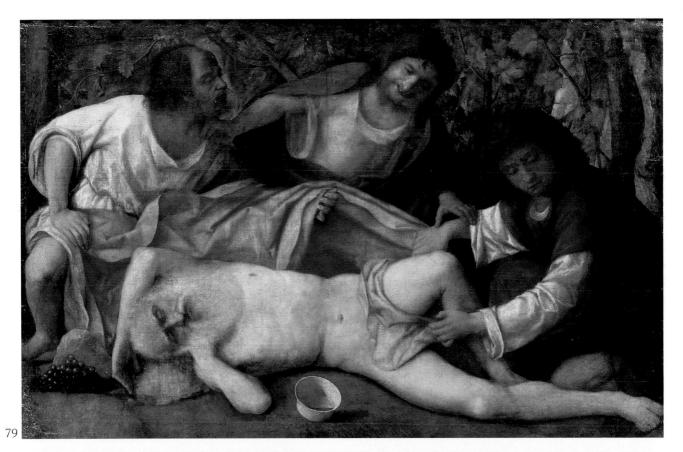

79

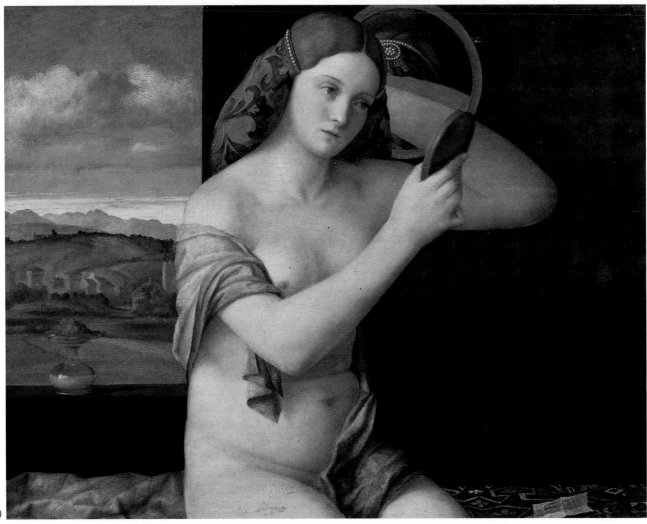

80

79. *Drunkenness of Noah*
103 x 157 cm
Besançon, Musée des Beaux-Arts

80. *Naked Woman in front of the Mirror*
62 x 79 cm
Vienna, Kunsthistorisches Museum

81. *Young Bacchus*
48 x 37 cm
Washington, National Gallery of Art

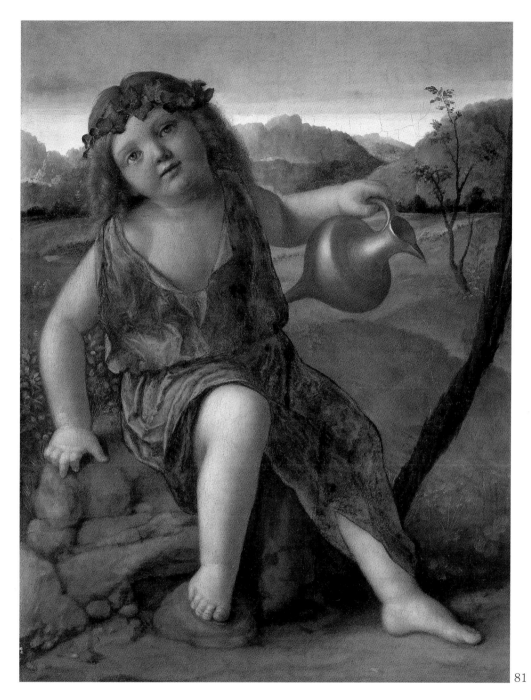

81

the subsequent necessity to alter the composition in order to adapt it to a different literary source. The presence of the young Bacchus and the two satyrs, originally intended by Bellini, would not oblige us to identify in the other members of the group an original divine nature, but would merely represent the tangible sign wanted by the artist to refer to the theme of the Bacchic mysteries.

In 1515 Bellini signed and dated the *Portrait of Teodoro of Urbino* of the National Gallery in London. The old prelate appears here as St Dominic, solemnly clothed in a black robe. The unusual flowered curtaining and the customary three-quarter pose do not diminish the physiognomical impact of this mask, which is actually accentuated by the meagre colour and by the far-away leftward gaze. At the same time

the artist, who was now over ninety years old, worked on the large canvas with the *Martyrdom of St Mark*, commissioned to him the previous year by the Scuola Grande di San Marco, now the Municipal Hospital of Venice. Left unfinished at his death it was completed and signed, eleven years later, by Vittore Belliniano.

On 29 November 1516 Marin Sanudo wrote in his *Diaries*: "News came this morning of the death of Zuan Belin, excellent painter. . . whose fame spread throughout the world, and though he was very old he painted most excellently". Bellini's brother-in-law Andrea Mantegna had died ten years earlier in 1506; Gentile, his brother, in 1507. While Mantegna and Gentile Bellini had always been, albeit in a very different way, consistent unto themselves right to the end, Giovanni Bellini, though always absolutely coherent,

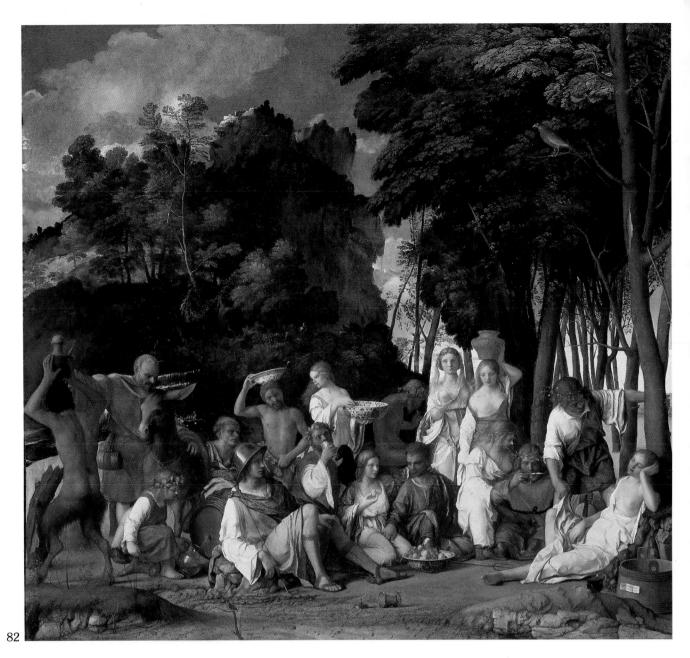

82

finished far beyond where he had first started. His extremely long artistic career, at least sixty years of activity at the highest level, had all been lived "between innovation and conservation" (Pallucchini, 1964).

Like Raphael, he had had a prodigious ability to keep abreast of new developments without ever annulling or contradicting, but on the contrary thoroughly utilizing, his link with tradition.

From the Venetian and Byzantine legacy he had passed, through various phases, to Mantegna, Piero della Francesca, Antonello da Messina and finally Giorgione, without ever losing his self-identity and a remarkable and unmistakable continuity. As with Raphael, his extreme balance had attained an extreme harmony; but much more than with Raphael, poetry had been the inspiration and the end of his art.

82, 83. Feast of the Gods
170 x 188 cm
Washington, National Gallery of Art

84. Portrait of Teodoro of Urbino
63 x 49,5 cm
London, National Gallery of Art

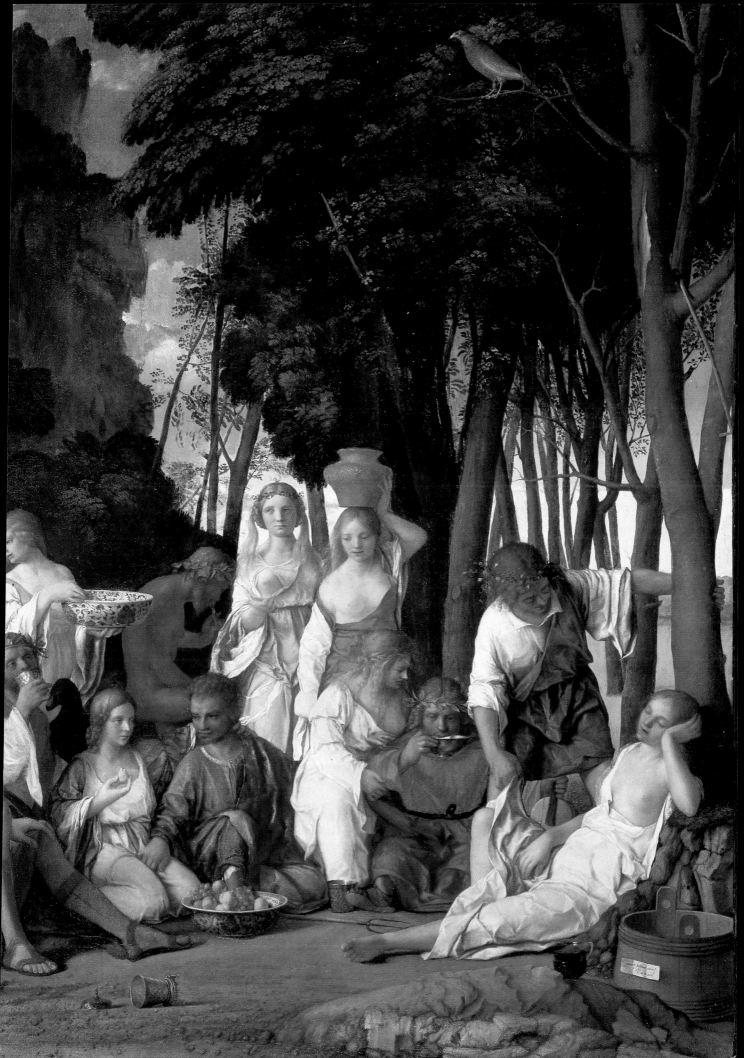

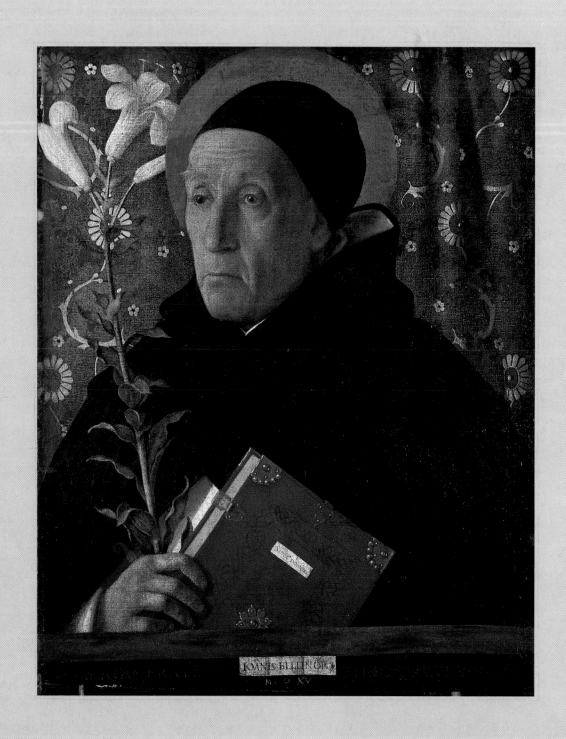

Index of illustrations

Other authors:

Short bibliography

R. PALLUCCHINI, *Giovanni Bellini*, Milan 1959.

F. HEINEMANN, *Bellini e i belliniani*, Venice 1962.

G. ROBERTSON, *Giovanni Bellini*, Oxford 1968.

T. PIGNATTI, *L'opera completa di Giovanni Bellini*, Milan 1968.

N. HUSE, *Studien zu Giovanni Bellini*, Berlin 1972.

M. LUCCO, *Venezia fra Quattro e Cinquecento*, in "Storia dell'Arte Italiana", vol. 5, pp. 447-477, Turin 1983.

VARIOUS AUTHORS, *La Pala Barbarigo di Giovanni Bellini*, in "Quaderni della Soprintendenza ai Beni Artistici e Storici di Venezia", 3, Venice 1983.

H. BELTING, *Giovanni Bellini – Pietà*, Frankfurt 1985.

VARIOUS AUTHORS, *La pala ricostituita*, Venice 1988.

Rona Goffen's monograph on Giovanni Bellini (Yale University Press, New Haven and London) was published in the last months of 1989, when this work was being printed. It has therefore been impossible to take into account the views expressed and datations proposed by the scholar in the above-mentioned study. It is right however to refer to at least one of the theories advanced by Goffen, that concerning the two "Presentations at the Temple" traditionally attributed to Mantegna and Bellini. According to Goffen the initial idea for the composition was Bellini's, a fact proved by the typology of the figures of St Joseph and the rabbi, as well as by the presence of the dark background, all elements typical of Bellini. However, Goffen maintains that the Bellinian original is lost and that the painting from the Querini Stampalia in which she points out some weaknesses is only a workshop copy.

Mantegna's painting, in which Goffen recognizes the autography of the Mantuan, would also be derived from this lost hypothetical prototype: consequently, the two persons portrayed to the right and left of the central group cannot be Andrea and his wife Nicolosia Bellini.

85. Barbarigo Altarpiece Murano, Church of San Pietro Martire

85